John Garrett's
Black-and-White Photography Masterclass

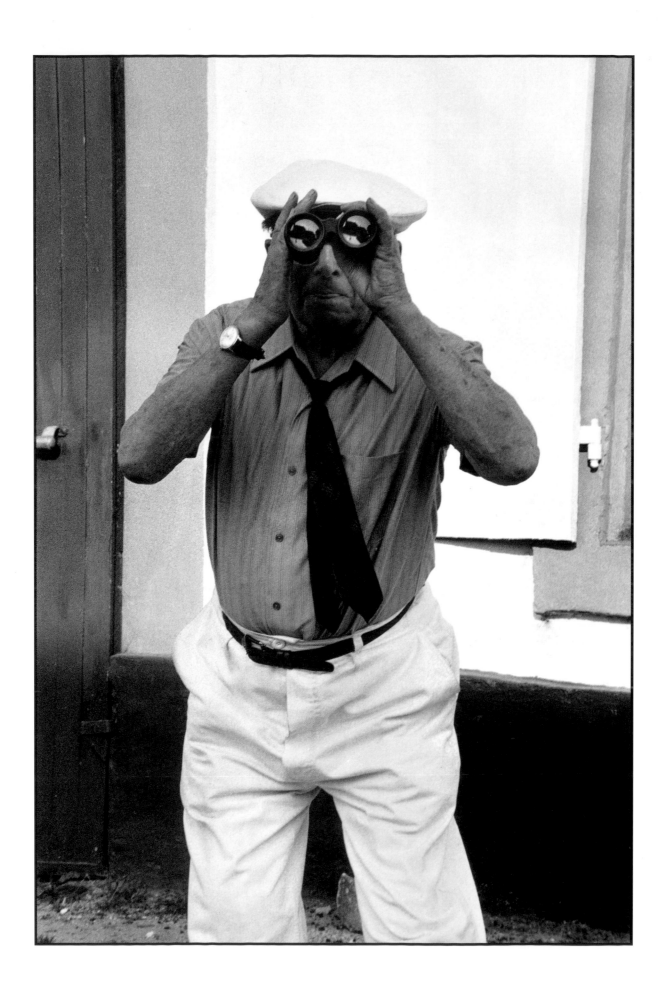

John Garrett's

Black-and-White Photography Masterclass

Amphoto Books

An imprint of Watson-Guptill Publications/New York

Copyright © 2000 Collins & Brown Limited
Text copyright © 2000 John Garrett
Photography copyright © 2000 John Garrett

First published in the United States in 2000 by Amphoto Books
an imprint of Watson-Guptill Publications
a division of BPI Communications, Inc.
1515 Broadway, New York, NY 10036

First published in Great Britain in 2000
by Collins & Brown Limited

The right of John Garrett to be identified as the author of this work
has been asserted by him in accordance with the Copyright,
Designs and Patents Act, 1988

Library of Congress Cataloging-in-Publication Data

Garrett, John.
 John Garrett's black-and-white photography masterclass/John Garrett.
 p.cm.
 Includes index.
 ISBN 0-8174-4044-5
 1. Photography — Amateurs' manuals. I. Title: Black and white photography
 masterclass. II. Title.

TR146.G226 1999
771—dc21 99-044599

A BERRY BOOK
Conceived, edited, and designed by Susan Berry for
Collins & Brown Limited.
Editorial Director: Sarah Hoggett
Editors: Chris George and Paul Harron
Designer: Roger Daniels

Printed in Hong Kong

1 2 3 4 5 6 7 8 9/08 07 06 05 04 03 02 01 00

I dedicate this book to
my sons, Nick and Matt,
who have always been
an inspiration.

Contents

Introduction

I grew up with great black-and-white images all around me. The newspapers, magazines, movies, and newsreels produced powerful black-and-white pictures that are indelibly printed on my memory.

Although I have probably shot more color pictures as a professional photographer than black and white, I have always came back to black and white for my personal pictures. The recent comeback of black and white means that I now shoot mostly monochrome.

Now is a great time to be shooting in black and white. The film technology has improved considerably, and many of the paper manufacturers have relaunched papers that have not been on sale since the 1960s. The development of multigrade and resin-coated papers has made printing much more accessible.

This is not a manual covering all aspects of black and white. It is an insight into how I visualize a picture and the techniques I use in the darkroom.

I have often been frustrated by photographic books, as they only print the best picture and then tell me how they did that. But I want to see the other frames and other prints that led up to that final print. I have tried to imagine the reader as one of my assistants who I take out on the shoot, explaining what I'm visualizing and the techniques I've decided on and why, and then going back to the studio, explaining the processing and all the darkroom decisions that lead to the final print.

I have no interest in photographic technique for its own sake. Technique is only the method to bring my visualization onto paper or transparency. Henri Cartier-Bresson, Edward Weston, and Richard Avedon were great masters, but you are bowled over not by the technical excellence, but by the images.

But this book is not about the zone system. Since Ansel Adams invented his system of exposure and development, the materials available have changed dramatically. The film emulsions have far greater latitude, finer grain, higher resolution, and much faster usable film speed than they used to. I don't believe the production of a good negative is as critical or difficult as it used to be. Using sophisticated camera metering — and a good film and developer match — a good exposure and a printable negative are just a matter of fine-tuning. We all have screw-ups, but if you can print well you can get acceptable prints from most negatives — thick or thin.

My career is unusual in that I have covered an enormously broad area of work. I was a fashion and beauty photographer in London during the so-called Swinging Sixties. During that time I also shot major advertising campaigns for anything from automobiles to cosmetics. I moved into reportage in about 1970, and this area of photojournalism and portraiture has been the foundation of my work ever since.

Reportage is where you must learn to print well because conditions are often difficult. I remember processing negatives in my hotel bath when covering the Indo/Pakistan War in 1971–72. The developer, from a Calcutta camera shop, was a vicious brew, and the enlarger was made out of jam tins with a bottle for a lens (almost) — but the prints were acceptable. Much of my technique is now second nature, so I do not want to minimize how vital good technique is. In this book I have tried to analyze my own technique step by step, so that readers can understand my methods and then develop their own.

Most importantly, I believe we mustn't look at our pictures that didn't work as failures or mistakes, but rather as learning steps. We are all lifetime students when it comes to black-and-white photography.

▶ **Cowboy with attitude**

I had to stop to allow the cattle drive through in Colorado and shot this picture out of my car window. The low camera angle, very tight framing, and the use of a red filter to boost the contrast make him look a formidable character.

80–200mm zoom lens at 120mm; Delta 400 rated at ISO 320; 1/500 sec at f/8. Printed on Forte Warmtone FB for 20 secs; f/5.6 at grade 3. Highlights on shoulder burned in for 3 secs at grade 3.

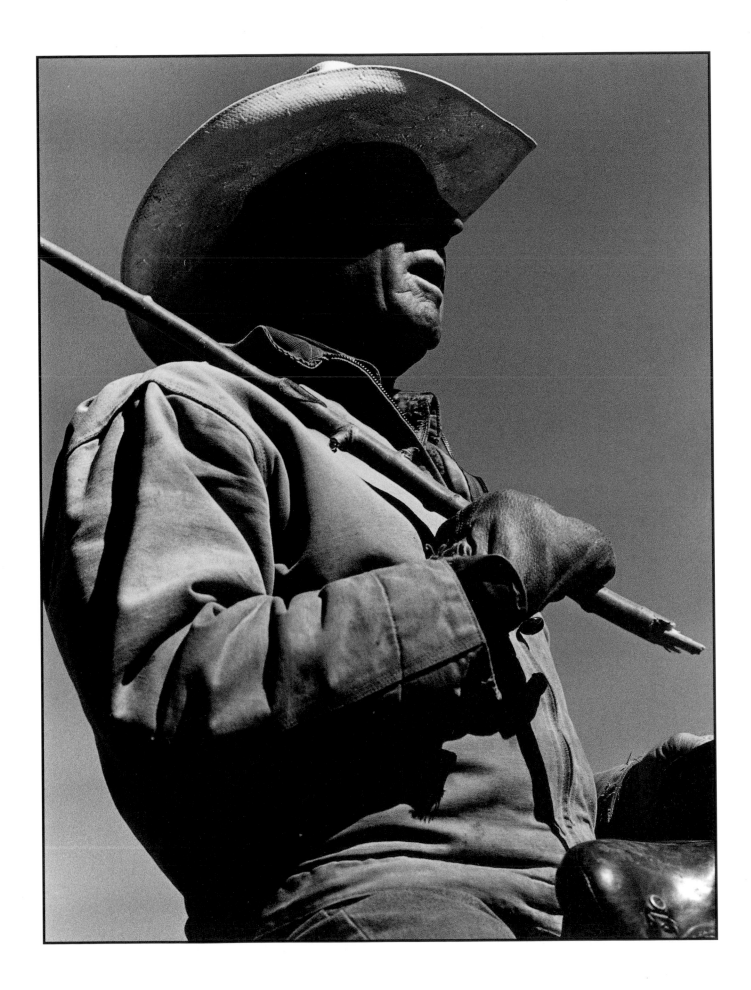

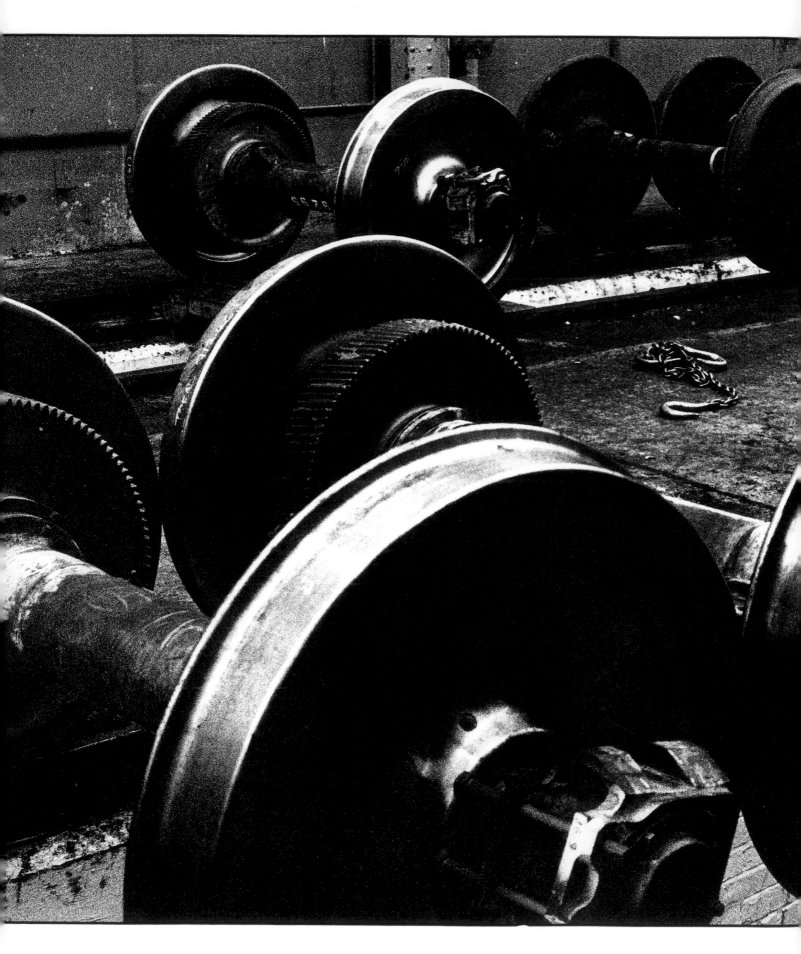

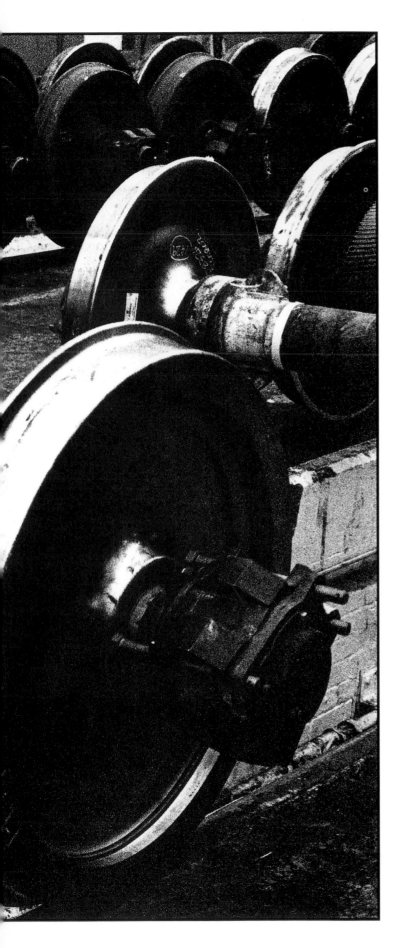

Seeing in black and white

◀ The big wheels

One of a series of pictures taken in the repair shop of London Underground. I loved the composition of the wheels but was frustrated by the lack of a focal point. I found the chain and popped it into the gap. The focal point has broken up the previously boring gray tone in the middle of the frame.

80–200mm zoom lens at 120mm; HP5+ rated at ISO 800; $^1/_{125}$ sec at f/11. Printed on Forte Warmtone FB for 20 secs; f/5.6. Shadows of foreground wheels held back for 5 secs.

Seeing color as tone

▶ **Color version**

A faithful reproduction of how the eye actually sees the image.

35–105mm zoom lens at 105mm; Fuji Velvia; ¹/₁₂₅ sec at f/8.

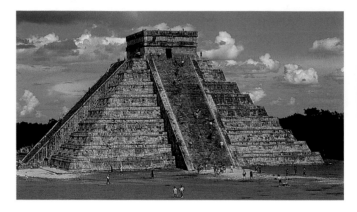

The moment you load your camera with black-and-white film, you make a major creative decision — one that means having to look beyond what is seen in the viewfinder. When you take a color photograph, you make a number of choices governed not only by composition but also by the interplay of the colors themselves. In black and white, you make the image that touch more abstract, as there is no color, but you have to make a leap of imagination and interpret the colors as tones.

If you don't allow for the way in which colors are translated, you will end up with disappointing pictures. As the diagram on the right shows, two colors that look completely different in nature can become the same shade of gray when shot in black and white.

A good starting point for learning how to see in black and white is to fiddle with the controls on your television set and eliminate the color completely.

▶ **Black and white: increased drama**

By moving the camera lower, the sky becomes more dominant. This also adds to the drama, throwing the pyramid into greater relief. I wanted greater contrast between the highlight and the shadows; by waiting until a suitable cloud formation appeared, the contrast between the pyramid and the background is increased.

35mm lens; FP4+; ¹/₁₂₅ sec at f/8. Printed on Sterling VC for 12 secs; f/5.6 at grade 2¹/₂. Sky burned in for 4 secs.

◀ **Color to black and white**

This shows how colors at opposite ends of the spectrum appear remarkably similar when seen in black and white. This is because their tonal density is actually similar, even though the color can be seen to be different.

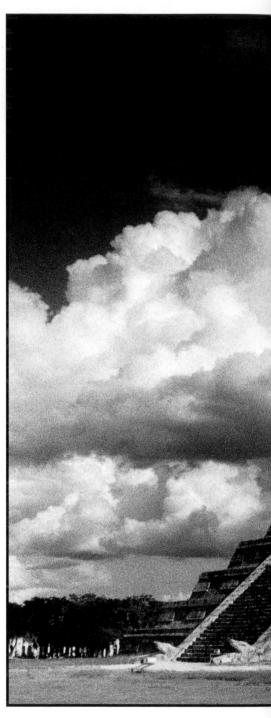

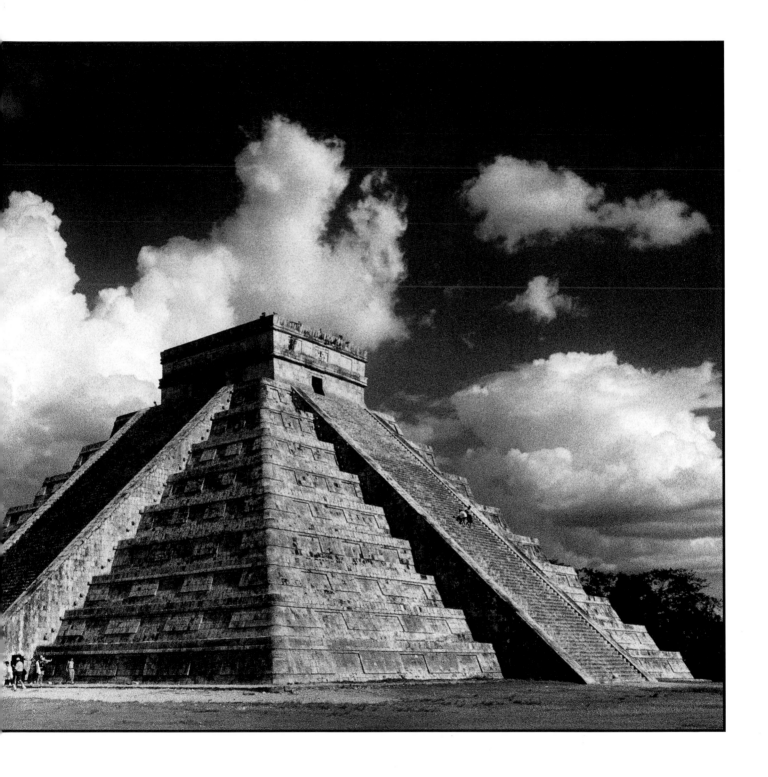

Using filters

Filters for black and white are a decisive way to change the tonal contrast. I mainly use orange and red filters to increase contrast and produce dramatic skies. The darkening of a blue sky really emphasizes the cloud formation. An orange filter reproduces the tones as you see them, while a red filter is used to exaggerate the tonal contrast.

Yellow, orange, and red filters are also effective for portraits. These filters lighten skin tone and have a cosmetic effect, lessening spots, and so on.

Experience has taught me that exposure and development of the negative are the most important technical considerations when using filters. The increased contrast can leave you with a thin negative with no shadow detail, if you expose using the camera's meter. When using an orange filter, I add ½ to ⅔ stop to the exposure, and with a red filter I add 1 to 1⅓ stops. I then reduce the development time slightly, to ensure that I don't produce too contrasty a negative. When I come to make the print, I may find that I

have more shadow detail than is wanted, but I can always get a print out of it.

I remember reading Ansel Adams' description of how he had shot one of his famous images of the Half Dome at Yosemite. The picture he saw in his camera didn't have the drama that he felt for the landscape. He added a red filter, and immediately he had a picture that captured how he felt. Adams' visualization really hit a chord. The use of filters is, very often, the difference between how I see a subject and how I feel about it.

▲ Yellow filter

Shot with a yellow filter. There is some tone in the sky, but it is rather a bland image.

▶ Orange filter

Shot with an orange filter. The contrast has increased. The foliage and the sky are darker, producing a more faithful image.

▶ Red filter

Shot with a red filter. The contrast has been increased even further with the red filter, producing a more exaggerated version of the orange-filter picture.

All pictures: 35–105mm zoom lens at 35mm; T-Max 100 rated at ISO 80; ¹/₂₅₀ sec at f/8–f/11. Straight printed on Ilford MGD 25M for 15–20 secs; f/5.6 at grade 3.

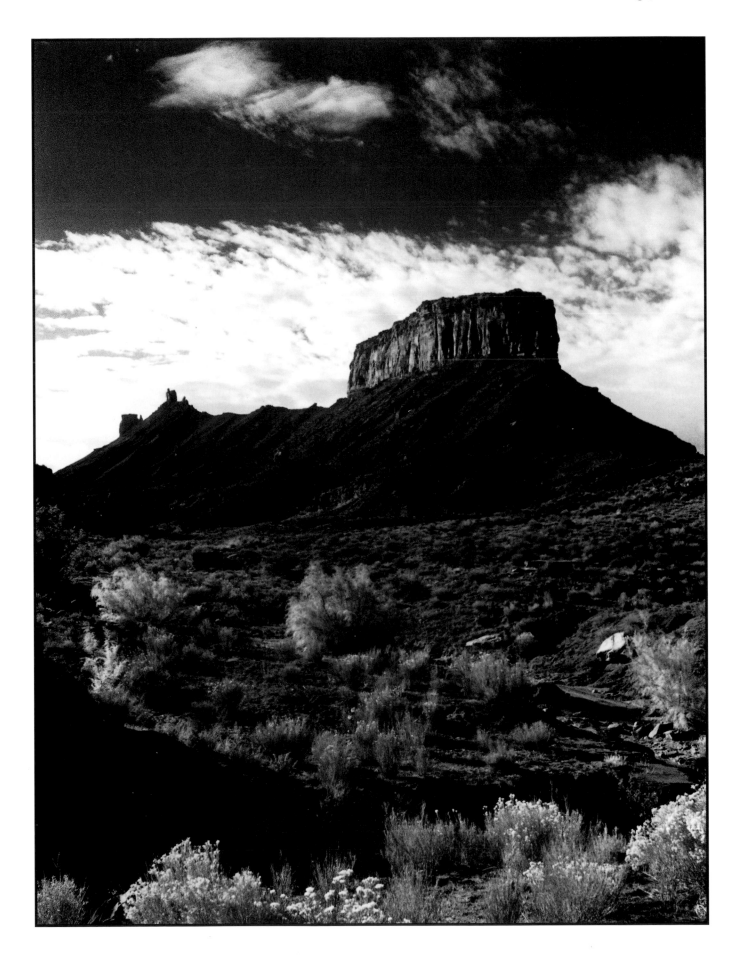

Using light

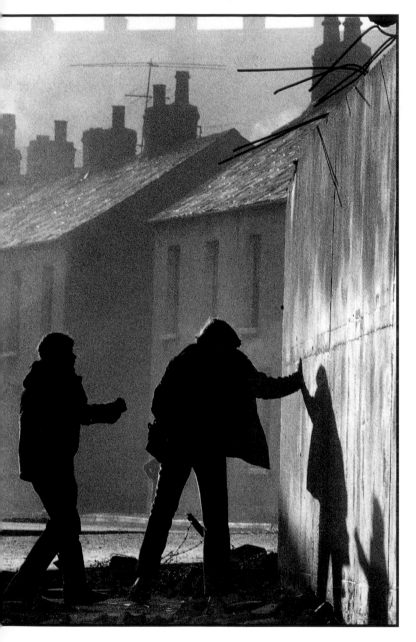

◄**Northern Ireland**
This is a totally light-dominated picture, shot during a confrontation between the army and the youth of Londonderry. The early-morning sun makes a powerful backlight. I made no attempt at shadow detail, but just used the silhouettes and shadows the light gave me.

105mm lens; T-Max P3200; ¹/₅₀₀ sec at f/16. Printed on Ilford MGD 25M for 13 secs; f/5.6 at grade 3. Roofs and top of hill burned in for 5 secs at grade 1½.

More often than not, it is the quality of light that inspires me to take a picture. I have walked past a scene many times without being creatively stirred, and then, seeing the same subject magically lit by late-afternoon sun, have been knocked out by how photogenic it has become.

Light transforms all things and dominates the tonal balance of a black-and-white photograph.

I dislike the terms good light and bad light. Bad light for which subject? Overcast, low light may not be ideal for a dramatic landscape, but it is soft and flattering for a portrait.

What photographers need to learn is how to "read" light — how any quality of light, whether natural or artificial, transposes onto film.

The ability to read light makes other decisions easy. Your selection of film is dominated by light quality, and the developer you choose is also related to the light.

As you improve your ability to read the light, your composition will automatically improve too, as it is light quality that dictates the all-important tonal balance.

When it comes to artificial light, the way to learn is by observing natural light and then reproducing that light quality in the studio.

My advice to all photographers new to black and white is to put your flash gun away in a drawer for a while. The modern reliance on flash kills the richness of available-light photography. This trend is especially odd when we now have such superb high-speed films.

▲ **Mining village, northeast England**
Early-morning winter sunshine gives a cold, hard look to everything it hits. The low, three-quarter backlight adds to the drama.

105mm lens; T-Max P3200; ¹⁄₅₀₀ sec at f/16. Printed on Ilford MGD 25M for 13 secs; f/5.6 at grade 3; top of picture burned in for 5 secs at grade 1½.

Tone as shape

The big step from taking attractive color pictures to making strong black-and-white images is taken when you start to see subject matter as tonal shapes. It is how we organize these tonal shapes inside the viewfinder that determines whether our shot is strongly composed.

The physical world is an infinite combination of patterns that, as black-and-white photographers, we need to reduce to monochromatic patterns. We don't need to create tonal shapes and tonal patterns — we only have to find and isolate them in the viewfinder.

To compose in tones you need to be able to "read" light and to understand filtration. Coming to grips with the craft of printing will contribute to your ability to tonally manage your images.

Both these prints are really just exercises in making tonal patterns. The content was pretty irrelevant. Both situations possessed the tonal properties that could be manipulated in the darkroom into semi-abstract compositions.

▶ Shadow on the stairs

The pattern of the stair rail and the extreme range of tones attracted me here. I just added the silhouetted woman to complete the composition.

24mm lens; T-Max P3200 rated at ISO 1600; $^1/_{125}$ sec at f/8–f/11. Printed on Ilford MGD 1M for 14 secs; f/5.6 at grade 4. Top right corner burned in for 6 secs at grade 2; glass door burned in for 20 secs at grade 2; shadow area bottom left burned in for 6 secs at grade 4.

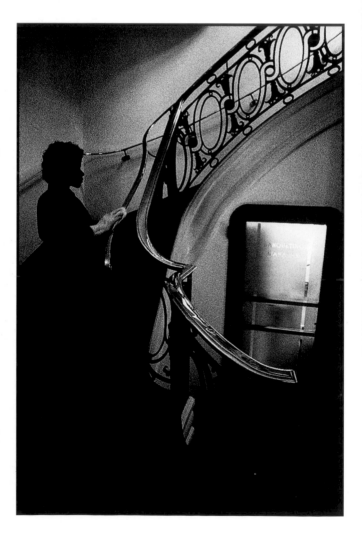

▲ Happy accident

I noticed that this cloud was just about to cross the sun. The contrast in the negative between the cloud and the building is huge. I decided to flash in the highlights (see pp 110–11). I overdid the flash, and the Sabattier effect (see p118) developed. Sometimes accidents have happy endings — I decided I liked the look of the way that the cloud has, by this effect, partially become a negative, and used this print.

28mm lens on Fuji Super Mini compact; T-Max P3200; approximately ¹/₅₀₀ sec at f/16. Printed on Ilford MGD 25M for 12 secs; f/5.6 at grade 3. Sky burned in for 20 secs at grade 1¹/₂; print flashed during development, and developed until the Sabattier effect appeared.

Less is more

When you decide to take black and white seriously, you need to adopt a new approach to composition. The design adage of the modernist architects, "Less is more," applies beautifully to black-and-white composition. I feel that the less I have in the frame, the better the final print becomes. Photographic compositions rely more on the photographer's ability to get rid of the ugly than to search out the beautiful. Beautiful is easy. There is profound beauty all around us, but so very often when trying to capture this beauty on black-and-white film, there are ugly bits in the frame that spoil the picture. The classic examples are rubbish on the ground or a telegraph pole growing out of a head — but more often than not, it is just poor tonal management that jars the eye. Maybe the tonal shapes are too complex and numerous, or there is a slab of light tone that is in the wrong place.

My advice is to keep your composition very simple to begin with. Look for one dominant, tonally-positive shape around which you can build the picture. As you become more confident, you can make your composition more complicated — but not much!

▶ **Dark symmetry — two horses and a dog**

This composition is all built around the beautiful, almost black, shape of the horse. It is one of those reportage compositions that your learned compositional instincts force you to take at exactly the moment when all the elements come together. When the horse spun into profile across the road, I instantly saw that the dog in the bottom left of the frame was balancing the other horse in the top right — and pushed the button. This composition lasted only a fraction of a second. The lens is important to this composition. The 180mm telephoto lens setting has compressed the perspective, pulling the shapes of the dog and the background horse closer to the main subject. The road has also been pulled up closer to create a light-toned, negative shape around the horse and rider.

80–200mm zoom lens at 180mm; T-Max 400; $^1/_{500}$ sec at f/5.6–f/8. Printed on MGW 1K for 14 secs; f/5.6 at grade 2$^1/_2$. Top right-hand corner burned in for 5 secs.

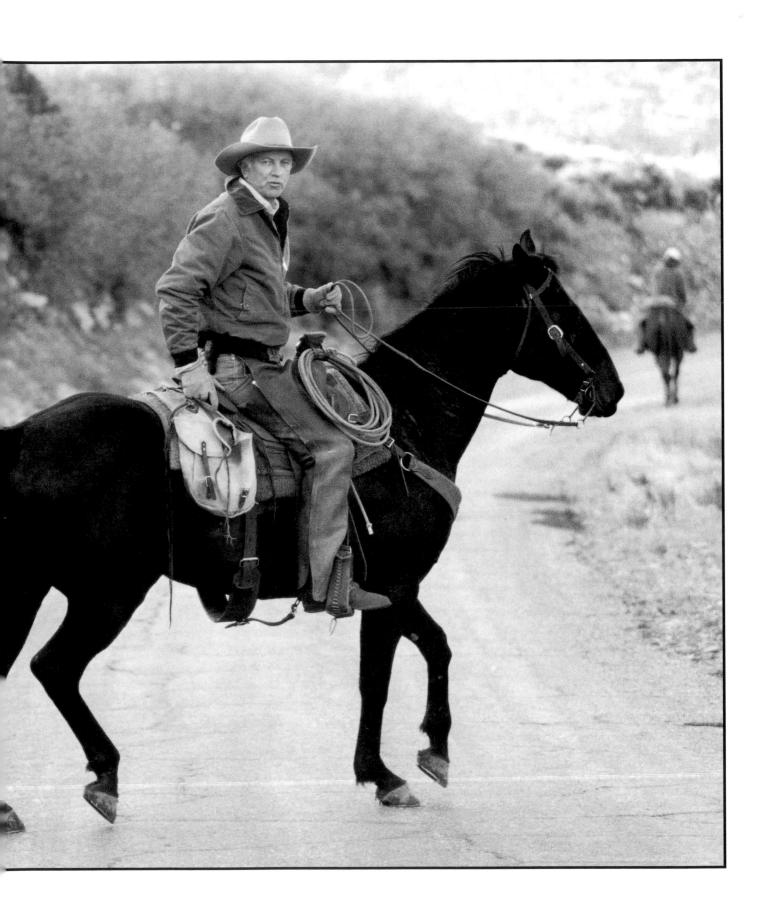

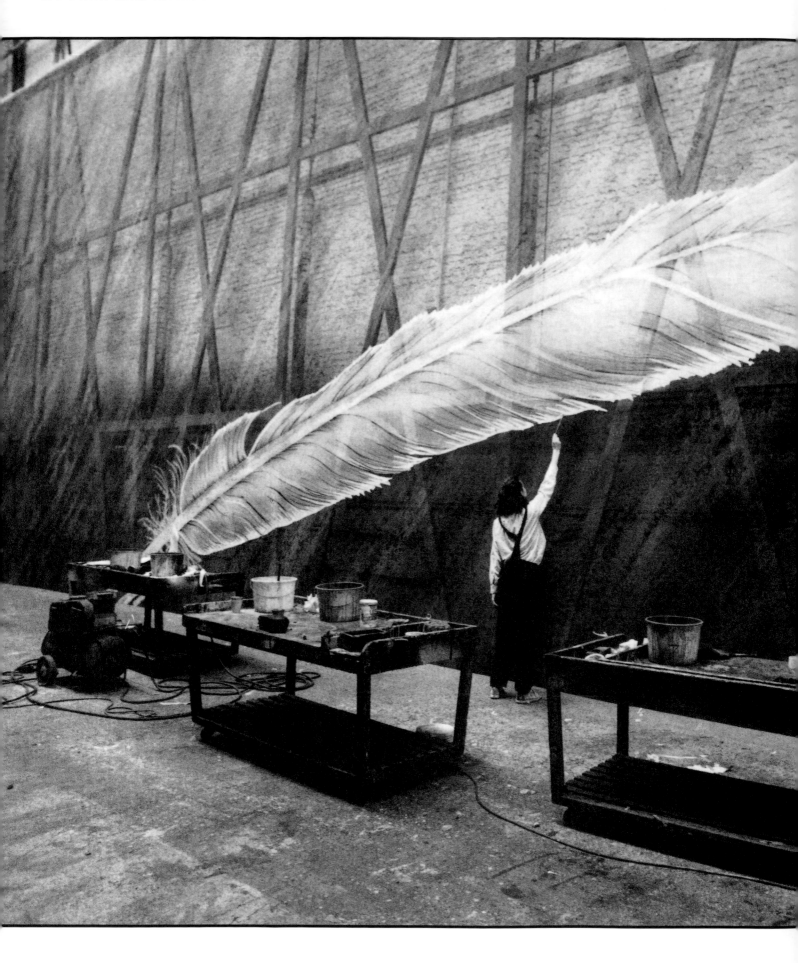

Film and format

◄ **Backstage at the Royal Opera House, London**

The great feather was obviously going to dominate my composition. I used the artist to bridge the tonal gap between the feather and the floor. This connection prevents the feather from appearing to float off the page.

24mm lens; HP5+ rated at ISO 1250; $^1/_{125}$ sec at f/5.6–f/5.8. Printed on Kentmere Art Classic for 25 secs; f/5.6. Area from feather upward burned in for 6 secs, background area below feather held back for 4 secs.

Formats

When it comes to choosing formats, I most naturally reach for my 35mm cameras. I have worked most of my career as a photojournalist, and Nikons have been my main tool of trade for over 35 years.

However, I also work on medium format a lot. The choice between 35mm and medium-format cameras is often dictated by a wish to change formats for compositional reasons. But there are also some situations that, at the time, seem tailor-made for a larger negative. This can produce a smoother tonal range and an almost grainless print, which is more suitable for some of my more formal pictures.

In my earlier days I shot a large percentage of my work on large format, both 5x4in and 10x8in. For the ultimate in fine grain, sharpness, and shadow detail, the large format is the way to go. But for me personally, I feel that I can produce sufficiently good quality on medium format.

The improved technology of black-and-white films has meant that my Hasselblad has now effectively become my large-format camera.

In real-life terms, I would just not produce the pictures I wanted to take if I had to carry a large-format camera and sturdy tripod for miles on location.

The two portraits on these pages help to show my decision

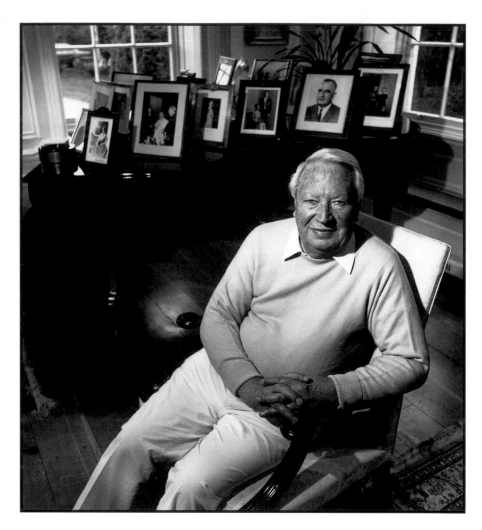

process when choosing formats. The assignment was to shoot a portrait of Ted Heath to illustrate his new book.

I chose my medium-format Hasselblad for the picture above, as this would give the best-quality negative for a flattering cover image.

However, at the end of the session I shot off some 35mm film, using available light alone. The 35mm shots have a casual and grainy look to them that lends a more documentary style to the portrait — and are arguably better suited to the portrayal of a politician who has spent most of his life in the news.

▲ **Medium format**

A portrait commission of Sir Edward Heath, the former British Prime Minister, which was to be used on the cover of his book on Europe. I decided to make some formal, medium-format portraits, which I lit with tungsten lights. I was after a smooth-toned, grain-free, flattering portrait. The 6x6cm negative has given me tonal detail in both highlights and shadow. I shot from a high angle to reduce the prominence of the double chin. I suggested that he dress in light colors so that he would make a strong diagonal across the dark background.

50mm lens on Hasselblad; FP4+; $^1/_{125}$ sec at f/5.6. Printed on Ilford MGD 25M for 14 secs; f/5.6 at grade 2½. Highlights on chair and right side of background burned in for 6 secs.

◀ **35mm**

At the end of the session I shot a roll of daylight 35mm portraits. I was after an alternative composition and a casual, spontaneous feel to give the cover designer a choice. The 35mm version is grainier but more "reportage" in feel. Both formats provided equally satisfactory looks; which you prefer comes down to personal taste.

105mm lens; HP5+ rated at ISO 800; $^1/_{250}$ sec at f/2. Straight printed on Ilford MGD 1M for 11 secs; f/5.6 at grade 3.

Creating the neg

Choosing the film is the most important decision in creating a negative. Generally speaking, the slower the film the higher its contrast, the finer its grain structure, and the sharper the image. Conversely, the faster the film the grainier it is and the softer is its contrast and the lower its acutance (sharpness).

There are four major groups of black-and-white films: very slow films (ISO 25–50); slow/medium speed films (ISO 100–200); medium/fast films (ISO 400); and very fast (ISO 1600 and higher).

It is the relationship between exposure and development that controls the negative quality.

Arguably, the most influential writer on exposure was Ansel Adams. Since Adams developed his famous "zone system", however, film emulsions have improved considerably. An average exposure and normal development now give a far greater tonal range than films were capable of in the past. This means that you can expose for the highlights and still hold printable shadow detail.

Whenever practical, I bracket exposures. Bracketing is often sneered at by the purists, but in my opinion it is stupid not to.

All the top manufacturers' films are superb these days, but I still agree with Ansel Adams that you can achieve the best tonal gradation by rating the film at a slightly slower speed than the manufacturers recommend. I expose ISO 100 films at ISO 64, ISO 125 films at ISO 80, and ISO 400 films at ISO 320.

Most photographer/printmakers are very conservative when it comes to films and developers. I am no exception. I have used Ilford's HP series, from HP3 through to HP5+, in partnership with Microphen developer, more than any others. HP5 and Tri-X have been the workhorse of the photojournalist for many years, simply because they are so versatile. They can be rated at ISO 320 and developed in Microphen or D76 to produce sharp, fine-grained images with a very large tonal range. Alternatively, they can be shot at ISO 1250 and pushed in Microphen to produce grainier and contrastier results than an ISO 320 rating.

At speeds faster than ISO 1250, I prefer to use T-Max 3200, Neopan1600, or Delta 3200 because they produce better shadow detail. When you push an ISO 100 or 400 film by more than 2 stops, you can continue to hold detail in the highlights but produce very little more in the shadows. But if needs must, you can push the traditional emulsions such as Tri-X and HP5+ by 3 to 4 stops and still get a printable negative. More recent films, such as Kodak's T-Grain and Ilford's Delta films, do not respond as well to push development.

▲ The negative

This negative has a full range of tonal information. It is the result of a combination of Tri-X film rated at ISO 320, Microphen developer, and soft window light. The shadows have been filled by the window light that is bounced off the white walls. The extreme highlights appear almost black (the window) and the deepest shadows appear white (nose shadow). I could print this negative satisfactorily on any grade of paper.

80–200mm zoom lens at 180mm; Tri-X rated at ISO 320; ¹/₂₅₀ sec at f/2.8.

▶ The print

Because the subject matter is rather gentle, I chose to print on a soft grade of paper (grade 1¹/₂). Another printer might well have preferred to print on grade 4 or even 5.

80–200mm zoom lens at 180mm; Tri-X rated at ISO 320; ¹/₂₅₀ sec at f/2.8. Printed on Ilford MGD 1M at grade 1¹/₂ for 12 secs at f/5.6; shadow of face held back for 3 secs.

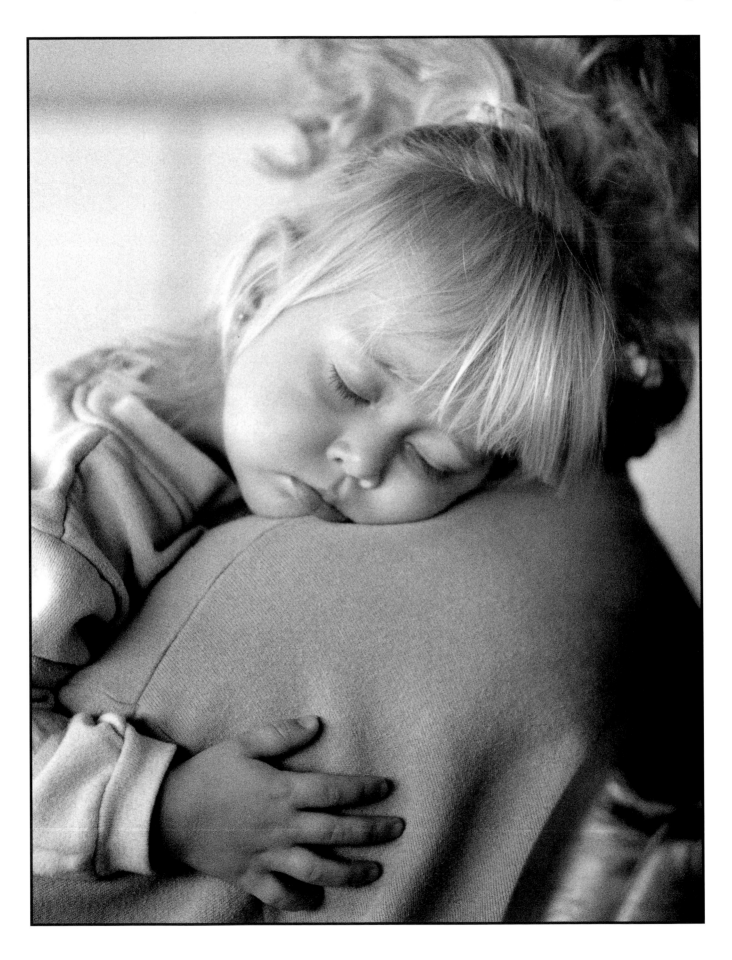

Slow and medium films

The very slow films, such as Agfa APX 25 and Ilford Pan F Plus, represent the ultimate in fine grain and sharpness. They are mainly used for architecture, landscape, and still life, but should be used with the manufacturer's own high-definition developer.

There is a large range of slow films: Ilford FP4+, Kodak Plus-X, and Agfa APX 100 being the market leaders for traditionally-grained films. All these films are very sharp and very fine-grained, but have a softer tonal graduation than the very slow films.

I have been using Delta 100 and T-Max 100 lately; the new-technology films have a greater tonal range. Delta 100 has greater flexibility with processing — results are excellent with any traditional developer (D76, Microphen, or HC110). T-Max 100 needs T-Max developer for best results.

ISO 400 films are the workhorses of the black-and-white photographer because of this great versatility. I have shot 75 per-cent of all my work on 400 range films. Rated at ISO 320 (a more realistic rating than ISO 400) and developed in Microphen, they give me a smooth, fully-toned negative.

For general reportage, I rate HP5+ and Tri-X at ISO 600 and process in Microphen. Pushing the film doesn't detract from the quality greatly, and the extra speed is useful when shooting inside and outside on the same film.

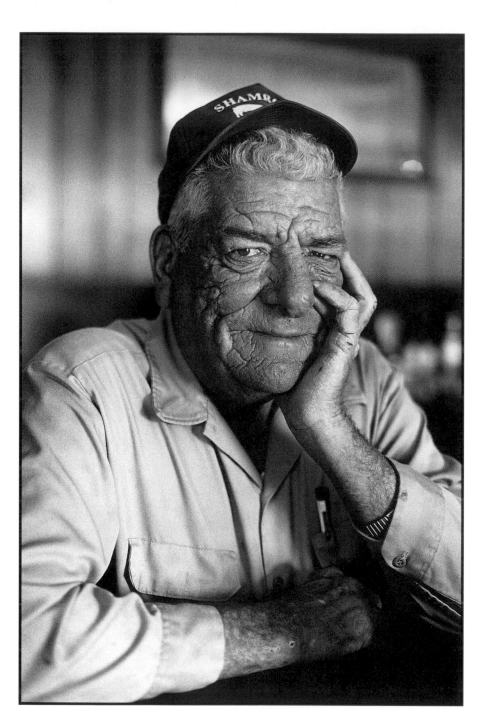

▲ **Medium-speed film — ISO 400**

50mm lens; HP5+ rated at ISO 600; ¹/₁₂₅ sec at f/5.6. Printed on Ilford MGD 25 for 14 secs; f/5.6 at grade 3. Forehead and shirt burned in for 4 secs at grade 1½.

▶ **Slow-speed film — ISO 25**

18mm lens; Agfa APX 25 rated at ISO 25; ¹/₁₂₅ sec at f/5.6. Printed on Sterling VC for 22 secs; f/5.6 at grade 3½. Highlights burned in for 4 secs at grade 1½.

Fast and infrared films

▲ **Go for grain!**
I was playing with
my compact camera
and overdeveloped
the film by mistake.
The result is a thick,
grainy negative.

*28mm lens; T-Max
P3200 rated at ISO
6400; 1/500 sec at
f/16. Printed on
Ilford MGD 25M for
14 secs; f/5.6 at
grade 4. Faces
burned in for 4 secs
at grade 2.*

◄ **Low light**
This backstage
picture is typical of
the orthodox use of
fast film. The light
was from a low-watt
tungsten bulb.

*135mm lens; T-Max
P3200; 1/125 sec at
f/2. Printed on Ilford
MGD 25M for 14
secs; f/5.5 at grade
3½. Face and
highlights burned in
for 3 secs at
grade 1½.*

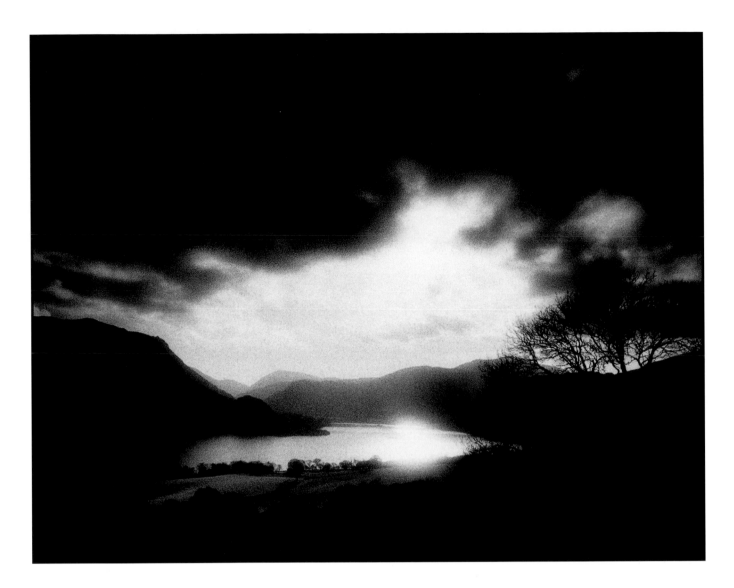

The range of fast films has really improved in recent years. Kodak's T-Max 3200 and Delta 3200 can be used at extraordinary film speeds — T-Max 3200, for instance, can be used at an incredible ISO 50000. The more you push them, the grainier they become.

Fuji Neopan 1600 is also an outstanding fast film; it doesn't boast quite the pushing potential of the others, but at ISO 1600 I think it is fine-grained. These films are useful for low-light reportage, but I also like using grain just for its graphic, textured look.

Infrared films produce an image from reflected infrared light. The resulting contrast is very high, so with a deep-red filter, blue skies will turn black, and foliage white. They also have the potential for cutting through mist and providing detail in distant mountains that is barely visible to the eye.

In summing up, I believe that all manufacturers overrate their film speeds and underestimate their development times. I inevitably give 15 percent more development time than recommended. Delta and T-Max films require double the normal fixing time.

▲ Infrared film

I used infrared film for this landscape, taken in England's Lake District. The effect is similar to shooting with a fast, grainy film (such as T-Max 3200) with a red filter and a soft-focus filter over the lens. There is no evidence of the foliage going white here, probably because the trees are backlit. The dark-sky, red-filter effect is more exaggerated than in normal film — there is no tone in the sky area; it is jet-black.

35–105mm zoom lens at 60mm with red filter (Wratten no. 25); Kodak High-Speed Infrared rated at ISO 200; $1/250$ sec at f/5.6. Printed on Ilford MGW 1K for 14 secs; f/5.6 at grade 2½. All highlights burned in for 16 secs at grade 1½.

Aperture priority

Both the shutter and the aperture are important to tonal management. Each one influences the sharpness of the tonal shapes — the shutter by controlling movement, and the aperture by controlling depth of focus.

The terms "aperture priority" and "shutter priority" are usually used to describe camera exposure systems, but they could also be used when making a tonal management decision. If the aperture and depth of field are critical for controlling the tonal composition of the shot, it is an aperture-priority composition. If the shutter speed is most important, so that tones are either sharply separated by using a fast shutter speed or merged together by using a slow shutter speed, it is a shutter-priority composition.

When controlling tone with the aperture, the question you need to ask yourself is: what am I trying to emphasize? With portraits, for instance, if I want to concentrate on the face I shoot wide open. But if I want an environmental portrait, I stop down and keep the background and foreground sharp.

► **Stopped down**

I didn't want a horse portrait, but rather a landscape shot showing the horse in the Scottish Highlands. I stopped down to keep the fence, horse, and mountains all sharp. The sharpness of the mountains was important, as I wanted a good edge to them. At f/4 they would have been out of focus, to the detriment of the tonal composition.

Hasselblad 50mm lens; HP5; ¹/₁₂₅ sec at f/16; red filter. Printed on Ilford MGD 1K for 22 secs; f/5.6 at grade 3¹/₂. Horse held back for 5 secs; sky and mountains burned in for 5 secs.

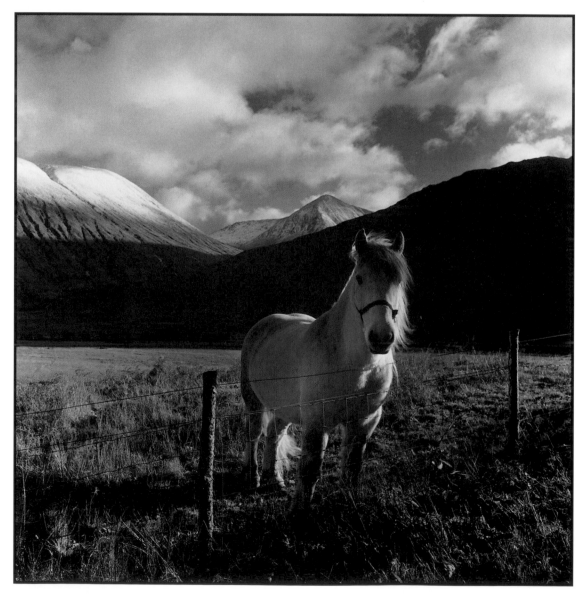

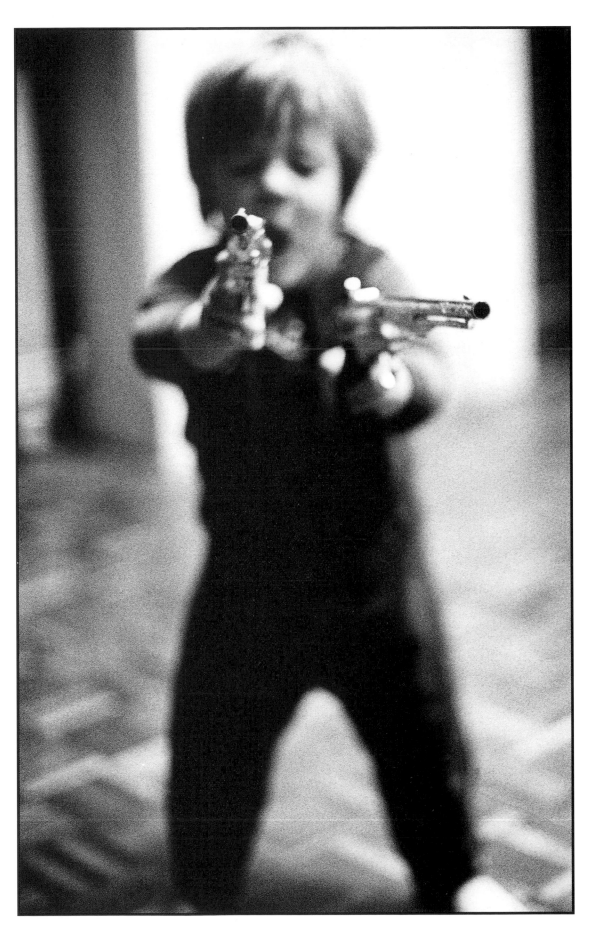

◄ **Wide open**

The picture of my son Matt gunning me down is an extreme example of how dramatic selective focus can be when shooting wide open. At f/1.2, the only sharp areas are the barrel openings of the guns. Even his hands are turning into soft, gray shapes.

50mm lens; HP5; 1/1000 sec at f/1.2. Printed on Ilford MGD 1K for 16 secs; f/5.6 at grade 3. Face held back for 3 secs; white background burned in for 4 secs at grade 1.

Shutter priority

When it comes to shutter-priority decisions, I personally shoot far more pictures on a fast shutter speed than I do on a slow shutter speed. My visualization is usually dominated by a need to freeze-frame life rather than let it blur on by. I use the shutter to help me precisely freeze the composition as it appears in the frame. I therefore have everything captured forever. I am probably confessing to being a control freak here. However, as you can see from the examples on pp 34–35, subjects do come up that nudge me to slow the shutter down and let things slide a little. The slow shutter provides a feeling of speed in an action picture.

A sports photographer shooting a 100-meter race must decide whether he is going to shoot on a slow shutter speed and create an impression of the speed of the runners, or go to fast shutter speed and freeze the moment so that he can see the power of the athlete, with every straining muscle sharply defined.

I may be a little rigid in my shutter-priority decision-making, and should look at more slow shutter interpretations. We all need to be conscious in our photography that there are always other ways of visualizing — and to attempt to open our minds to trying out these alternatives.

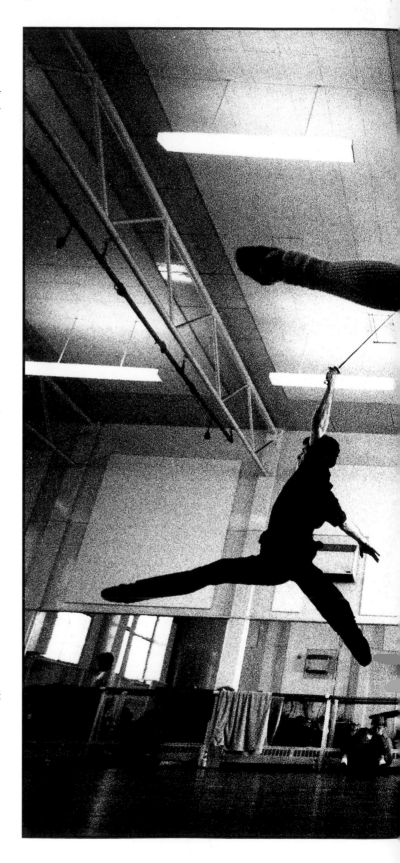

► **The leap**

By freezing the dancers with a fast shutter speed, I have been able to control the composition. I noted as the guys rehearsed that the foreground dancer made a frame for the picture when he flew past me in the foreground. I took the prism off my Nikon F4 and sat the camera on the floor. I made quite a few attempts at this shot until I got him spot on at the top of the frame. The frozen shape has made a frame within the frame. This composition is an attractive tonal combination with the light shape in the middle, and it successfully shows how incredibly athletic top ballet dancers really are.

18mm lens; HP5; $^1/_{500}$–$^1/_{750}$ sec at f/5.6. Printed on Ilford MGD 1M for 14 secs; f/4 at grade 3½. Corners burned in for 5 secs.

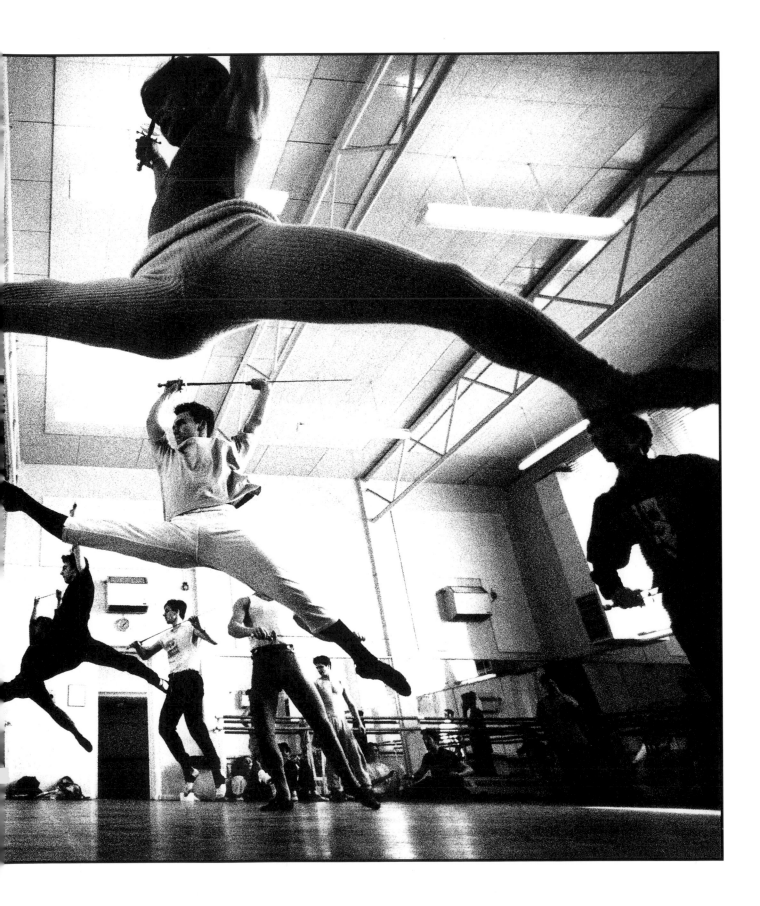

Blurring movement

Using a very slow shutter speed with moving subjects has a dramatic effect on the tonal composition. It is a photographer's version of an Impressionist painting, and is a very useful technique to keep in mind when you are faced with interpreting and capturing movement.

I had two shutter speed options for the Whirling Dervishes assignment (below). I could either have used a fast shutter speed (it would have required $\frac{1}{500}$ sec to freeze the spinning tribesmen), or a slow shutter speed (to give an impression of speed). I chose the slow shutter speed because I was interested in the patterns this could create.

Opposite is a shot I took for an engineering company. Here, a slow shutter speed was used to maximize the effect of the welder's sparks. If I had used $\frac{1}{125}$ sec, only a few sparks would have shown.

▼ **Whirling Dervishes**

35–105mm zoom lens at 40mm; HP5; $\frac{1}{4}$ sec at f/16. Printed on Ilford MGD 1M for 15 secs; f/4 at grade 2. Left-hand top and floor burned in for 7 secs.

► **The welder**

80–200mm zoom lens at 150mm with a monopod; HP5; ½ sec at f/22. Printed on Kentmere Art Classic for 24 secs; f/5.6. Flash used during developing.

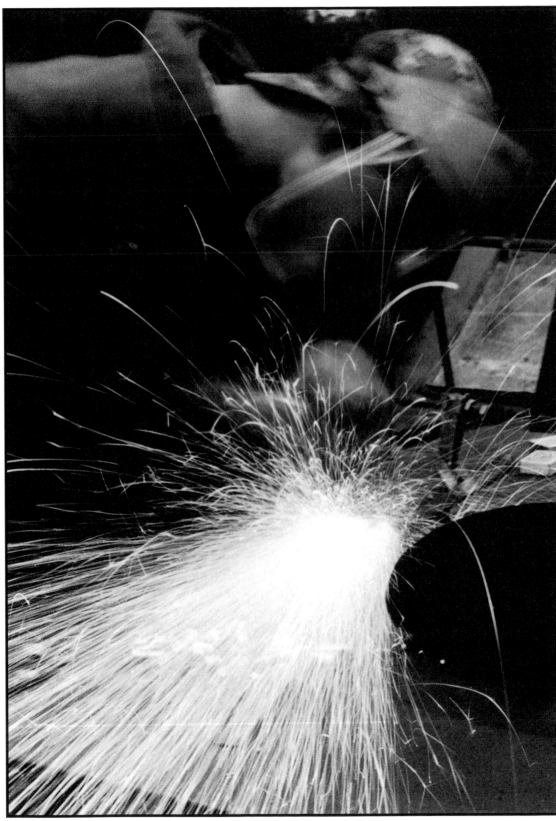

Exaggerating perspective

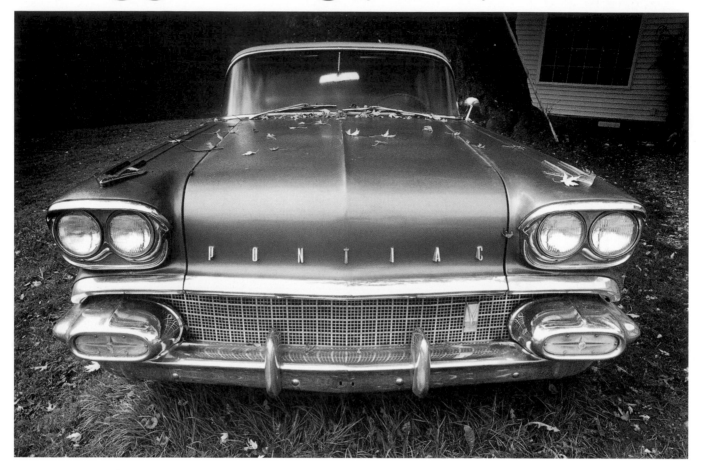

Most people use wide-angle lenses to "get more in" — but these short-focal-length lenses also have very useful creative properties. The wider the lens you use, the greater its depth of focus and the greater its ability to exaggerate perspective.

This combination of qualities provides us with interesting compositional possibilities. We can simultaneously change the tonal composition of a picture dramatically, and make the image very different from what our naked eye would normally see.

Because subjects in the foreground appear closer, and those in the background appear more distant, and smaller, than in real life, the very wide lens can provide an almost surreal interpretation of a subject by elongating and stretching it — even beyond recognition.

In tonal management, distorting the perspective means that you can "pull" some tonal shapes forward and "push" some back. By doing so, you completely alter the tonal arrangement of the picture that the viewer sees.

I often find it helpful to switch to a wide-angle lens when the composition looks dull — or when the pictures need "zing."

▲ Pontiac

The 24mm lens has exaggerated the impact of the flamboyant grille.

24mm lens; Tri-X; 1/500 sec at f/8. Printed on Ilford MGW 1K for 18 secs; f/5.6 at grade 3½. Background burned in for 12 secs at grade 2; grille held back for 5 secs; left side of bonnet and backdrop burned in for a further 3 secs at grade 2.

▶ Man at work

Using a wide-angle lens, I was able to create a powerful portrait of this window cleaner within his working environment — and also include his son bringing the bucket.

28mm lens; HP4; 1/250 sec at f/8–f/11. Printed on Ilford MGW 1K for 17 secs; f/4–f/5.6. Face held back for 4 secs; background burned in for 7 secs.

Telephoto lenses

Telephoto lenses were, of course, designed to get the photographer closer to distant subjects by magnifying the image optically.

However, telephotos have built-in properties that give us great creative possibilities. They offer the opposite choice in controlling perspective to wide-angle lenses. They condense perspective, making the background appear closer to the foreground than it would appear to the naked eye.

In a cityscape, a long telephoto lens gives the impression that the buildings are almost stuck on top of each other, and in a crowd scene people appear much closer together than in real life.

But there is another property of a telephoto that can be exploited by the photographer. The longer the focal length of the lens, the narrower is its inherent depth of focus — so there is less depth of field for a given subject distance and aperture.

The narrow depth of field when shooting with a wide aperture allows you to pick out a focal point and throw the foreground and background out of focus, reducing them to soft gray shapes. This is called selective focus and is a particularly useful compositional technique in black and white.

These two properties allow photographers to manipulate the tonal relationships or composition of a black-and-white picture.

▼ **Swans**

The 500mm mirror lens has converted the out-of-focus highlights off the water into doughnut shapes. The lens has altered the tonal pattern of the picture.

500mm mirror lens; HP5+ rated at ISO 600; $^1/_{2000}$ sec at f/8. Straight printed on Ilford MGD 1M for 20 secs; f/5.6 at grade 4.

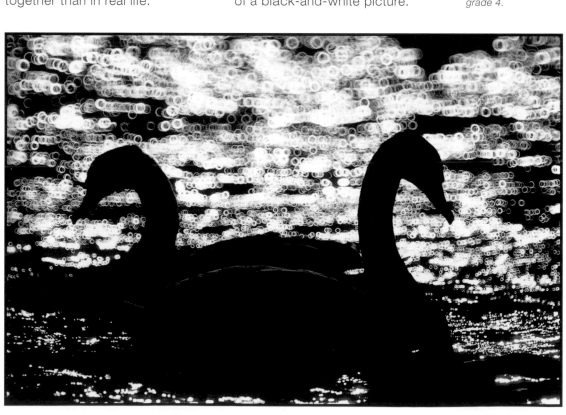

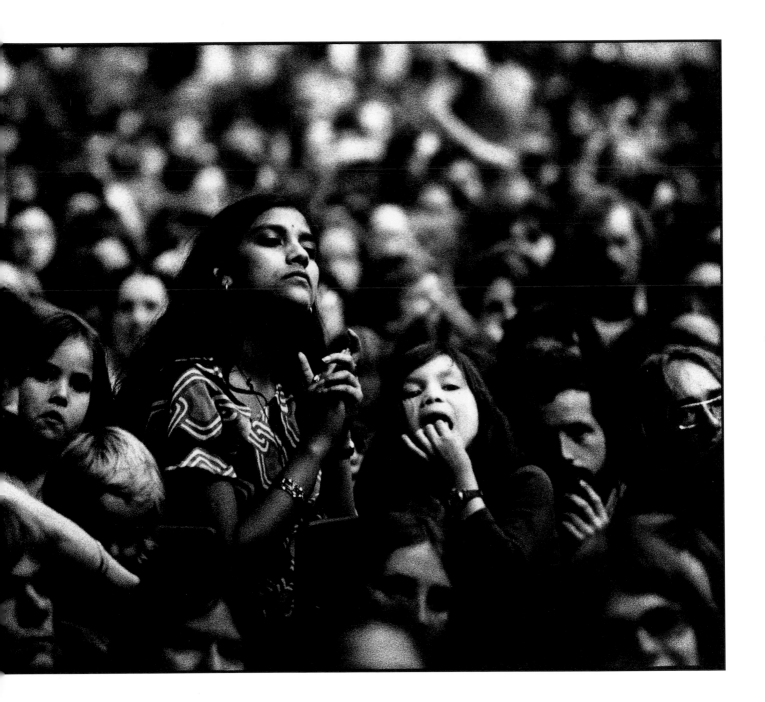

▲ Selective focus and compressed perspective

A 300mm telephoto has performed two jobs here. Firstly, because of its narrow depth of field, I have been able to "pick out" the faces that I chose from the audience (selective focus). Furthermore, the perspective has been condensed, so the crowd looks closer together than in reality.

300mm lens; HP5 rated at ISO 800; $^{1}/_{250}$ sec at f/4. Printed on Ilford MGD 1M for 14 secs; f/5.6 at grade 3½. Woman and child's face held back for 3 secs.

Creative use of lenses

One of the great joys of being a photographer rather than a painter is the opportunity to see the world through a huge variety of focal-length lenses. By visualizing the picture through a range of lenses, you can pump up the drama considerably.

A very good exercise to help you get to know your lenses is to shoot one shot with two extremes of focal length to vary the tonal composition. Just use the lenses you have — you don't need a 15mm or a 600mm to get the effects.

I have walked into a factory and my heart has dropped when I have picked up the camera with a normal lens and looked at a boring assembly line. But on the 300mm, with its perspective-condensing power, the picture looks great.

These pictures were taken at sunrise only a few minutes apart. One was shot with a 24mm lens, exaggerating the perspective, "stretching" the net out to look larger than in reality and "pushing" the fishermen further away from camera, making them incidental to the composition. The other shot uses a 200mm lens, which has "pulled" the sea up close to the fisherman. This picture becomes dominated by powerful black silhouettes against the strong lines of the waves. This is now a picture of a Kenyan fisherman rather than a seascape, and I believe the composition is that much stronger.

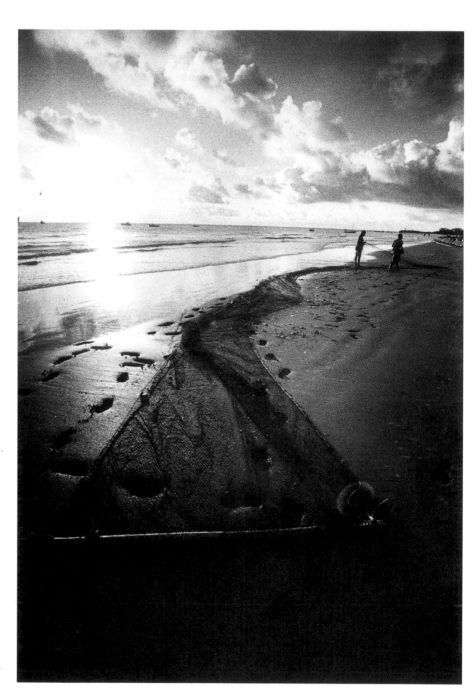

▲ **Option 1 — wide-angle lens**
20mm lens; HP4; 1/500 sec at f/11. Printed on Ilford MGD 25M for 12 secs; f/5.6 at grade 3. Sun burned in for 20 secs at grade 1; foreground net held back for 5 secs.

▶ **Option 2 — telephoto lens**
80–200mm zoom lens at 200mm; HP4; 1/1000 sec at f/11; red filter. Printed on Ilford MGW 1K for 15 secs; f/5.6 at grade 3. Water highlights burned in for 35 secs; foreground burned in for 20 secs.

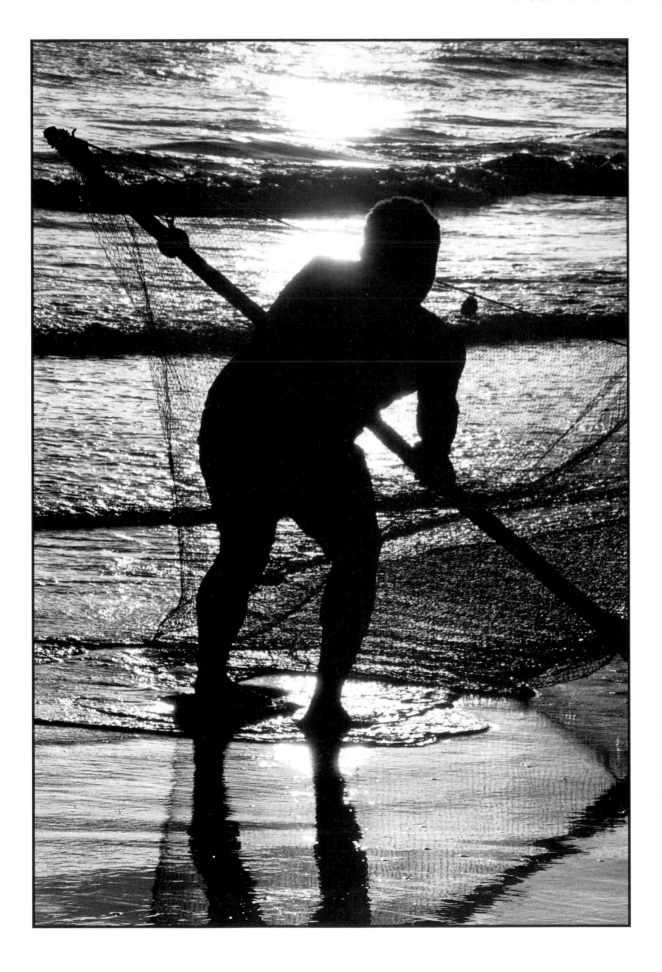

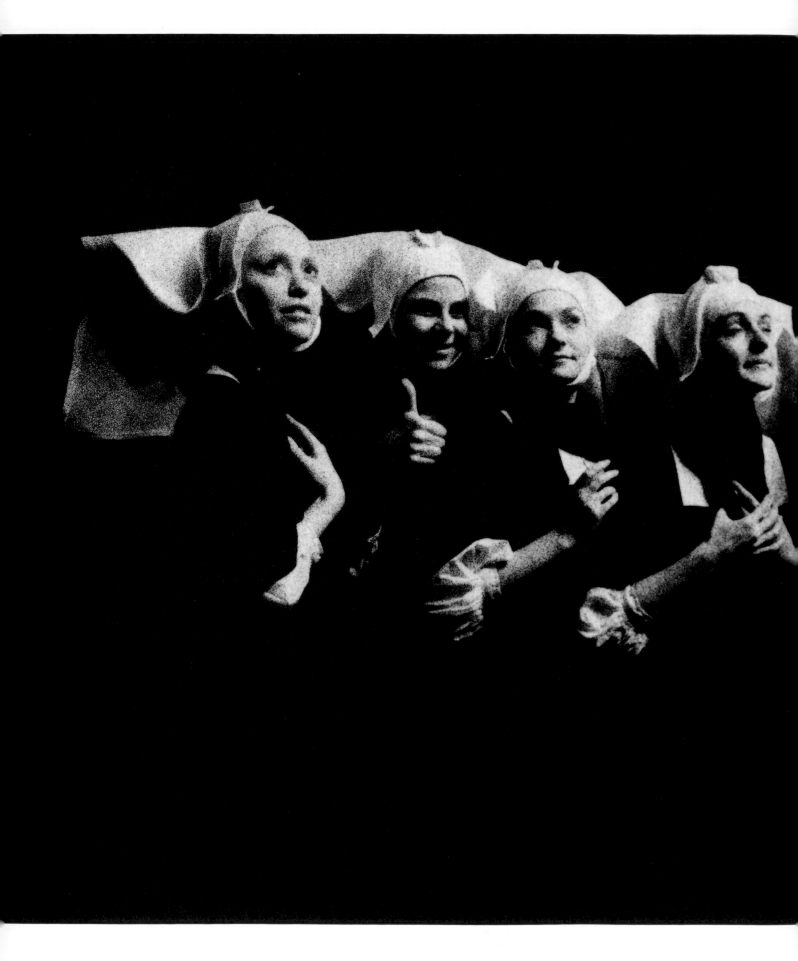

Composition

◄ **Backstage, Cyrano de Bergerac, Royal Opera House, London**

A very black-and-white composition, which relies on a pattern of light gray, continuous shapes floating in a black background. The negative shapes — the black areas — are as important to the composition as the positive shapes — the light tones of the nuns. The spaces between and surrounding the main subject matter in any photograph are shapes as well, and it is usually these negative shapes that create the tension or general mood of a picture. This is subliminal to most viewers of the picture, but as photographers we need to be conscious of negative space.

50mm lens; T-Max P3200 rated at ISO 6400; $^1/_{60}$ sec at f/1.2. Printed on Kentmere Art Classic for 20 secs; f/4–f/5.6. Veils burned in for 20 secs; bottom left third burned in for 15 secs; top right burned in for 10 secs.

Camera angles

Probably the most obvious way to change the composition of a subject is by changing the camera angle.

With all the complexities of design theory buzzing through our heads, we often forget the obvious — try looking at it from a different camera position!

Good photographic composition should, to my way of thinking, come out of a need to better tell the story, and to move people to feel the same way as I did when I pushed the button.

A dramatic change of camera angle — from high above your eye level or from way down low — can have a profound effect on the storytelling capacity of the picture.

As the two examples used here demonstrate, a fairly extreme change of angle can also greatly improve the tonal composition of a picture. Distracting, messy backgrounds can be eliminated if you kneel or lie down, for instance.

I have to admit to very often being guilty of shooting pictures from the first position I find, and not remembering to look for the alternative camera angle.

▼ **Worm's-eye view**

A low camera angle has had an immediate impact on the tonal composition of this group portrait. At normal eye level, the landscape in the background competed with the three women for the eye's attention. With the picture taken kneeling down, the trio are now framed against the obviously lighter sky.

28mm lens with orange filter; HP4; ¹/₂₅₀ sec at f/11. Printed on Ilford MGW 1K for 12 secs. All figures held back for 4 secs.

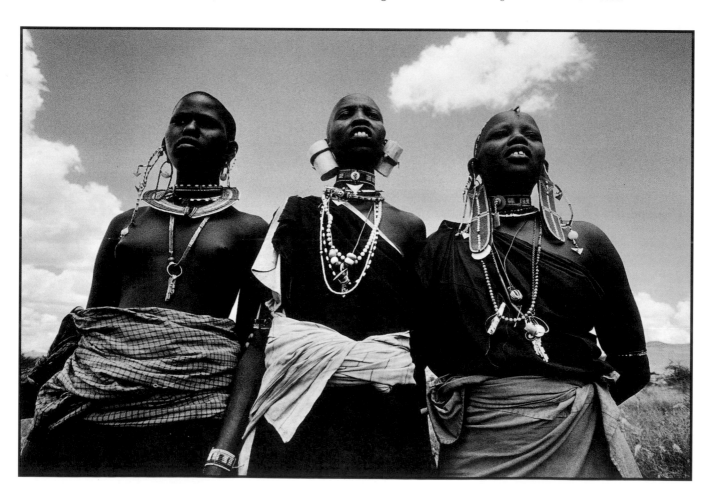

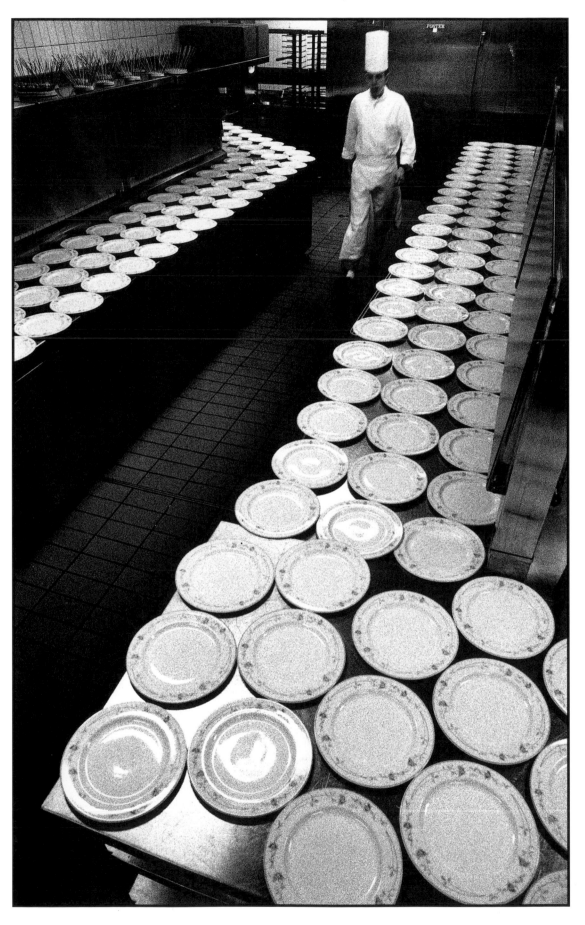

◄ Bird's-eye view

By shooting from an
elevated camera
position, I was able
to maximize the
pattern and strong
diagonal line created
by the plates.

*18mm lens; T-Max
P3200 rated at ISO
1600; $1/125$ sec at
f/5.6–f/8. Printed on
Ilford MGD 25M for
13 secs; f/5.5 at
grade 3$1/2$. Floor and
chef held back for 4
secs; plates burned
in for 7 secs at
grade 1$1/2$.*

Scale

Photographers — just like painters — use scale to demonstrate the size of a dominant feature of their picture. By placing an object of a familiar size within the frame, we comprehend the size of the main object in the picture. The grandeur of a mountain range, for example, can be enhanced by the inclusion in the frame of an auto or person.

But by playing with scale we can make the observer look at a subject from a different point of view — the point we are trying to make, in fact.

If the scale in the photograph is different to what you expect to see, the picture will be thought-provoking and can help the photographer to subtly get his or her message across.

Scale, or the manipulation of scale, is normally created by the photographer — most commonly by lens choice and camera angle (as in the portrait of Duke Ellington opposite). But sometimes you simply come across it as it manifests itself in the viewfinder (as in the shot of the airplane on this page).

▶ **Duke Ellington, Westminster Abbey**

The scale created with a wide-angle lens gives the mood for the picture. The dark shape of Ellington's manager looking down on him, and the vaulted ceiling above, make the Duke look vulnerable and frail. He died soon after.

Shot on 24mm zoom lens; HP4; $^1/_{125}$ sec at f/4. Printed on Ilford MGFB 1K for 15 secs; f/5.6 at grade 3½. Bleached back for 60 secs.

▼ **Farnborough air show**

Taken for a story on the arms race, I played with scale to make the bomber look like a toy taking off from the tail of a huge real plane.

80–200mm zoom lens; T-Max P3200; $^1/_{2000}$ sec at f/16. Printed on Ilford MGD 24K for 25 secs; f/5.6 at grade 3½. Bleached back for 60 secs.

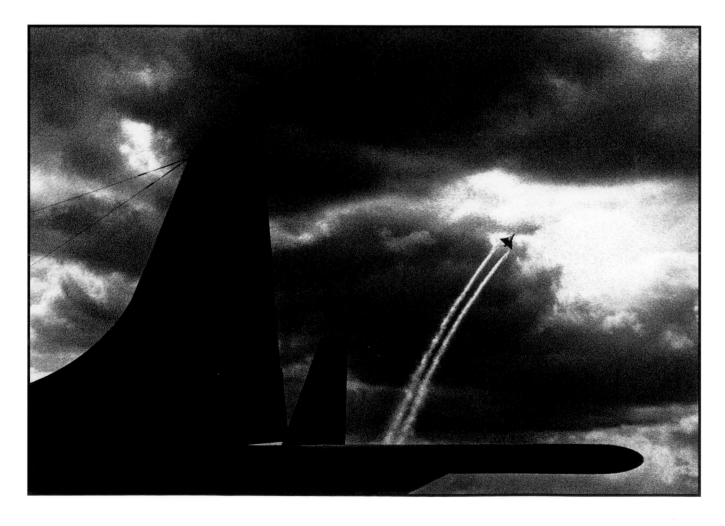

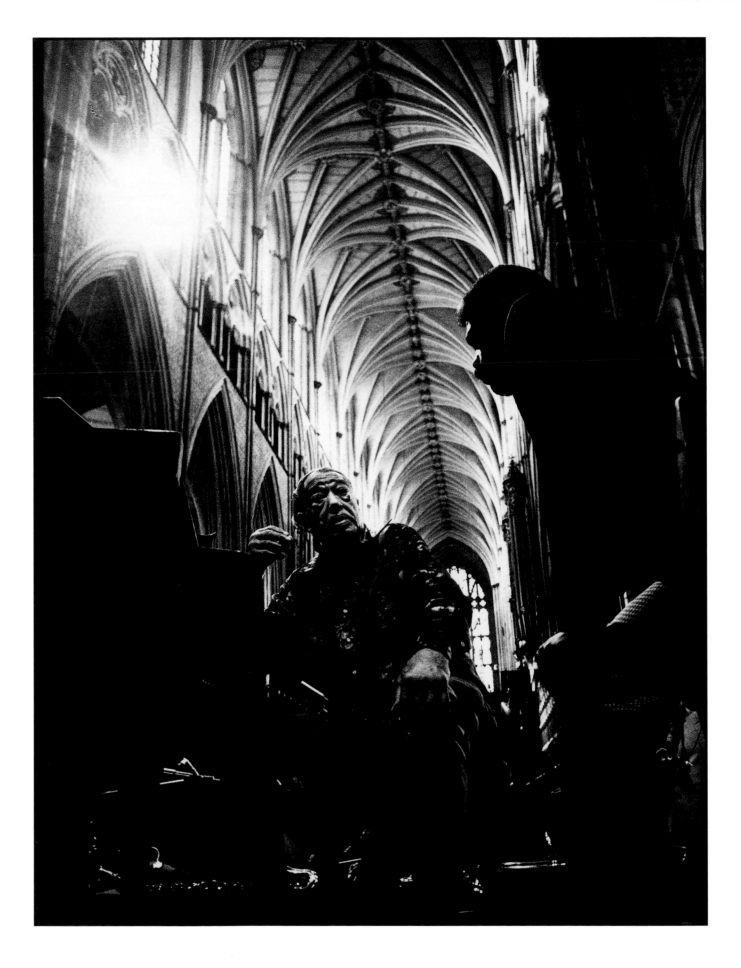

Seeing in tones

I came across this man training his horse late in the afternoon, when there was a wonderful, sharp, golden light and long shadows on the ground. I realized that the tension between the trainer and the horse on the end of the lunge rein could make a good photograph, but I also realized that the composition depended on the tonal contrasts.

In my first attempt, the man was training a gray horse and his wife had the black one. I quickly realized that the black horse would make a stronger tonal composition. With practice, you see the negative spaces around the shapes you are looking at, and not the objects themselves.

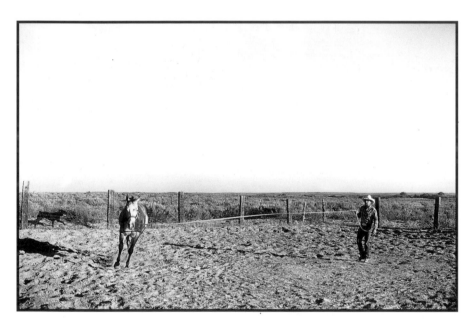

◀ **Weak contrast**

In this first shot, the man is training the gray horse, and as you can see, there is not really enough contrast between the horse, the paddock, and the skyline.

28–70mm zoom lens at 50mm; T-Max 100; $^1/_{250}$ sec at f/8. Straight printed on Ilford MGD 25M for 13 secs; f/5.6 at grade 3^1/$_2$.

▶ **Increasing the contrast**

He switched from the gray to this black horse, and I used a red filter to increase the drama of the sky and push the contrast up further. As I saw the horse come round, I realized I needed depth of focus and switched to a faster film. However, there is no compositional control in this shot — everything is on the same plane.

28–70mm zoom lens at 50mm with red filter; T-Max 3200; $^1/_{350}$ sec at f/11. Printed on Ilford MGD 25M for 14 secs; f/5.6 at grade 3^1/$_2$; sky burned in for 4 secs.

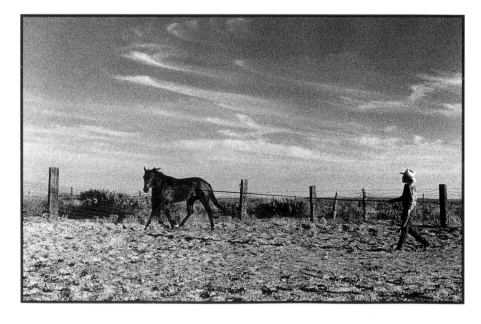

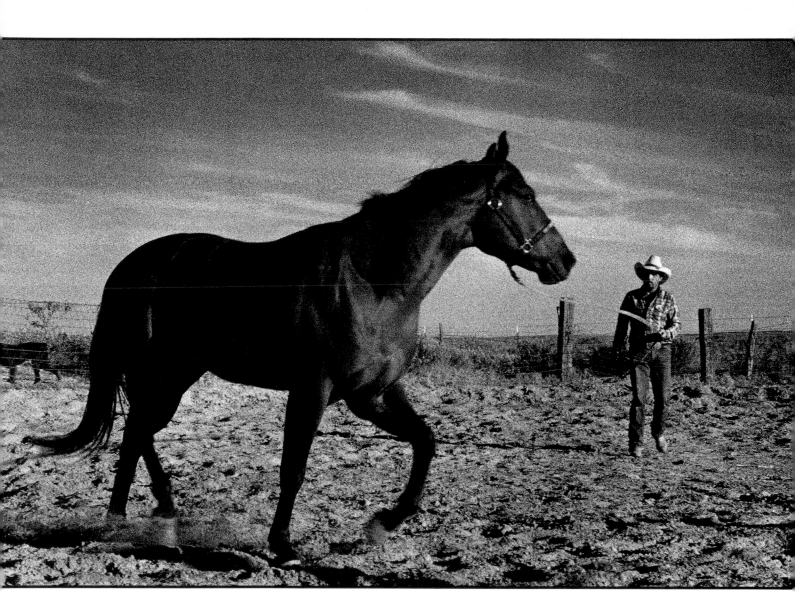

▲ Dramatic tension

As the horse moved around the paddock on the end of the lunge rein, I realized that it was a question of choosing the most appropriate moment — the point at which the contrasts were strongest and the tension was greatest.

28–70mm zoom lens at 70mm with red filter; T-Max P3200; 1/250 sec at f/11. Printed on Ilford MGD 25M for 15 secs; f/5.6 at grade 4. Horse shaded for 5 secs; sky burned in around shape of horse for 4 secs.

Symmetry

Symmetry, when used in architectural or garden design, does not usually provoke an energetic and emotional response. Symmetrical composition, similarly, has a calming or placid effect on the beholder.

In this picture of now-deserted docks, I composed symmetrically because the balance of the tones and shapes seemed to emphasize the lifelessness of a place that had once been full of life and energy. I was fortunate to have dark, rain-filled clouds that added to the somber mood.

The church in Taos, New Mexico (opposite), also seemed to cry out for a symmetrical composition. When you are recording someone else's work, as in architecture, you try to do it justice — making a sympathetic image of it, as it were.

The building has a harmonious symmetry in itself, so I tried to record that feeling. I think it is the symmetrical placing of the white crosses against the dark sky that makes the picture successful.

In both pictures I stopped down to a small aperture (f/11–f/16), to ensure that everything from foreground to background was sharp, and to get a hard edge to the tones. I used a slow (ISO 100) film for the church to get fine-grained sharpness. The cranes were shot on T-Max P3200 rated at ISO 1600, as I was interested in getting a moody image rather than in reproducing detail.

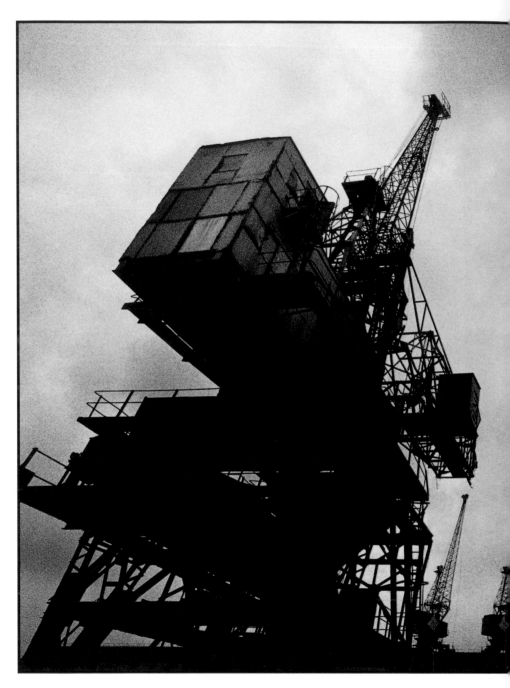

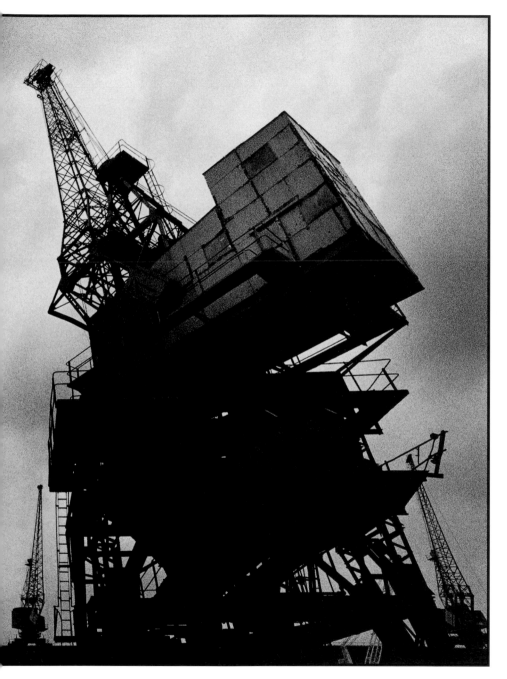

▼ Frame within a frame

I used a perspective-control lens to keep the verticals true. A red filter increased the tonal separation between the sky and the crosses.

28mm perspective-control lens with red filter; Agfa APX 100; ¹/₁₂₅ sec at f/11. Printed on MGD 1M for 14 secs; f/5.6 at grade 2¹/₂.

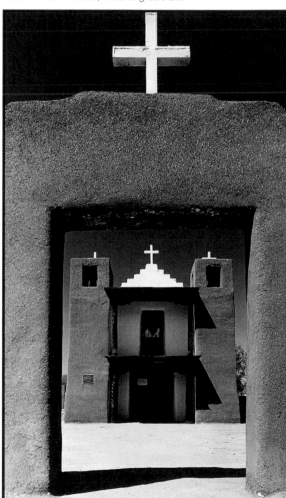

▲ Mirror image

In this symmetrical composition of redundant cranes on a quayside, I used a wide-angle (18mm) lens to exaggerate the perspective. This has made the two cranes in the foreground seem much larger in proportion to the ones in the background.

18mm lens: T-Max P3200 rated at ISO 1600; ¹/₃₅₀ sec at f/16. Printed on Ilford MGD 25M for 15 secs; f/5.6 at grade 2¹/₂. Crane cabins in foreground each shaded for 4–5 secs.

Group portraits

When composing with people — family groups, couples, teams, and so on — I often find myself concentrating too much on the personalities. The basic problems of making sure they are smiling, have their eyes open, and that the camera can see each person equally well, are difficult to handle. Dealing with the human equation sometimes means I forget that I am taking a black-and-white portrait and thus neglect the essential tonal composition.

When dealing with groups, take the trouble to compose methodically. The trick is to learn to slow yourself down; everybody has more time than you realize. Consider the tonal arrangements of your composition, and particularly how the people interact with the background. You can always try more than one approach, as I did in these shots of my son with his buddies.

Composing a group portrait is much the same as composing a still life. You just move the pieces around until you are satisfied with the composition. You have to be very much in charge — and determined that the group will follow your instructions.

The tonal arrangement is not totally under your control; it is not always possible to select the clothing yourself. If you can, choose dark, unpatterned clothes as this makes a single, dark shape that brings the group together.

▲ **One for the album**

The photograph above, of my son Matt and friends, is just a pleasant snapshot. The tonal composition is poor, mainly due to the dominance of the white area.
28mm lens; HP5 rated at ISO 600; ¹/₂₅₀ sec at f/8. Printed on Ilford MGD 25M for 12 secs: f/5.6 at grade 3.

▶ **In a different mood**

The barn wall and the framing tree make a good basis for this portrait. The rest was easy when the lads struck their "hard-men" poses.
80–200mm zoom at 80mm; HP5 at ISO 600; ¹/₂₅₀ sec at f/8. Printed on Ilford MGD 25M for 14 secs; f/5.6 at grade 3¹/₂; background burned in for 7 secs at grade 2.

Character portraits

When shooting portraits on location, you have the opportunity to use the environment to say something about the life and character of the subject. With careful composition, props and background can be used as visual symbols of the person's life.

Mr Ferguson runs a great outdoors shop in Colorado. I asked to take this portrait, and after the first two attempts, my schoolboy humor got the better of me and I couldn't resist having the antlers grow out of his hat. This is just a light-hearted picture, but it does highlight an important lesson: when composing

portraits, you are in control. Having been first attracted to the subject's personality or appearance, you just need to look at the situation from a graphic perspective. The person is a tonal shape that has legs and can therefore be moved to fit into your compositional visualization by simply asking nicely.

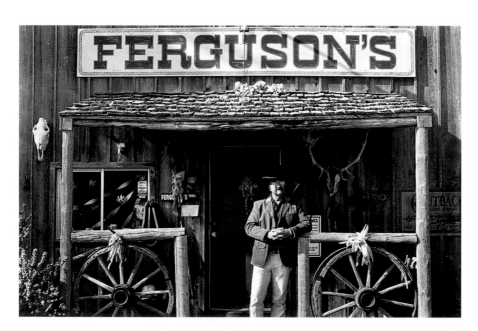

▶ **Gotcha!**

I moved Mr Ferguson under the antlers. Apart from the attempted humor, the composition is much stronger and less complicated. The tonal arrangement is much more harmonious. It is also a good example of how you can change your composition simply by turning a 35mm camera from horizontal to vertical.

35–105mm zoom at 80mm; Delta 100; ¹/₃₅₀ sec at f/8. Printed on Ilford MGW 1K for 16 secs; f/4–f/5.6 at grade 2½. Left-hand post and corner burned in for 6 secs; right-hand shadows held back for 5 secs; background around figure held back for 4 secs.

▲ **First snapshot**

A predictable portrait of a shopkeeper. Mr Ferguson stood in position and I shot the whole scene. It's a nice snapshot, but not much else.

35–105mm lens at 70mm; Delta 100; ¹/₃₅₀ sec at f/8. Printed on Ilford MGD 25M for 12 secs; f/5.6 at grade 2½.

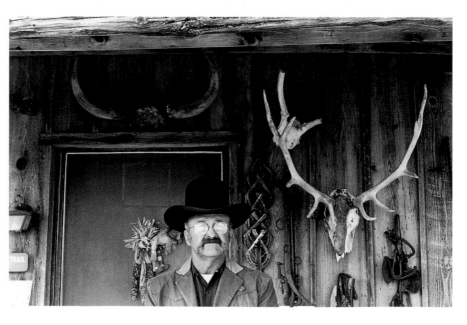

◀ **Closing in**

I came in closer to get a better view of the face and the antlers, but the shot is still too messy.

35–105mm lens at 90mm; Delta 100; ¹/₂₅₀ sec at f/8. Printed on Ilford MGD 25M for 12 secs; f/5.6 at grade 2½. Horns above door held back for 3 secs.

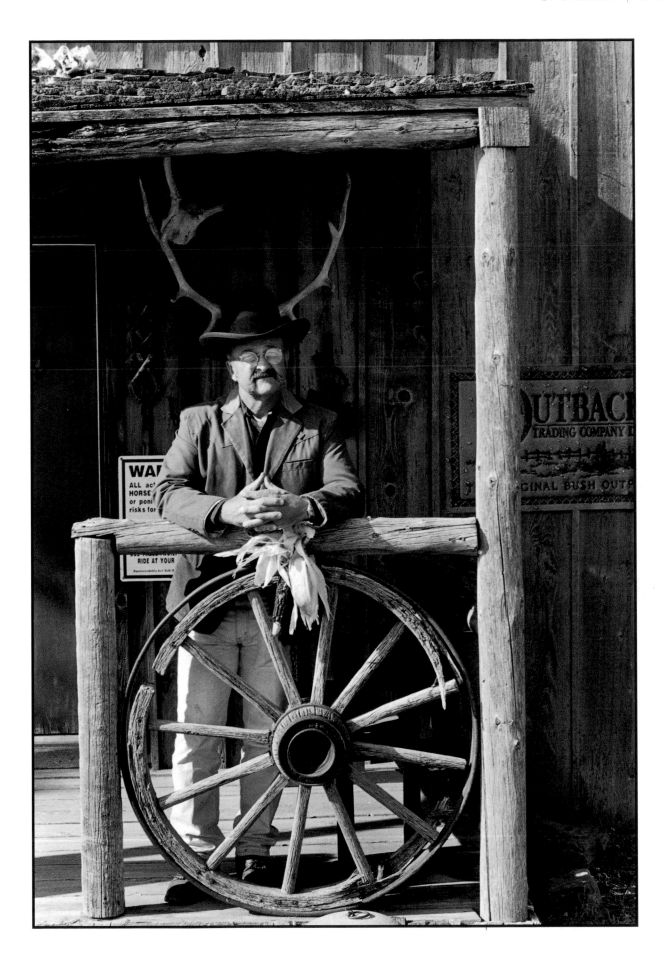

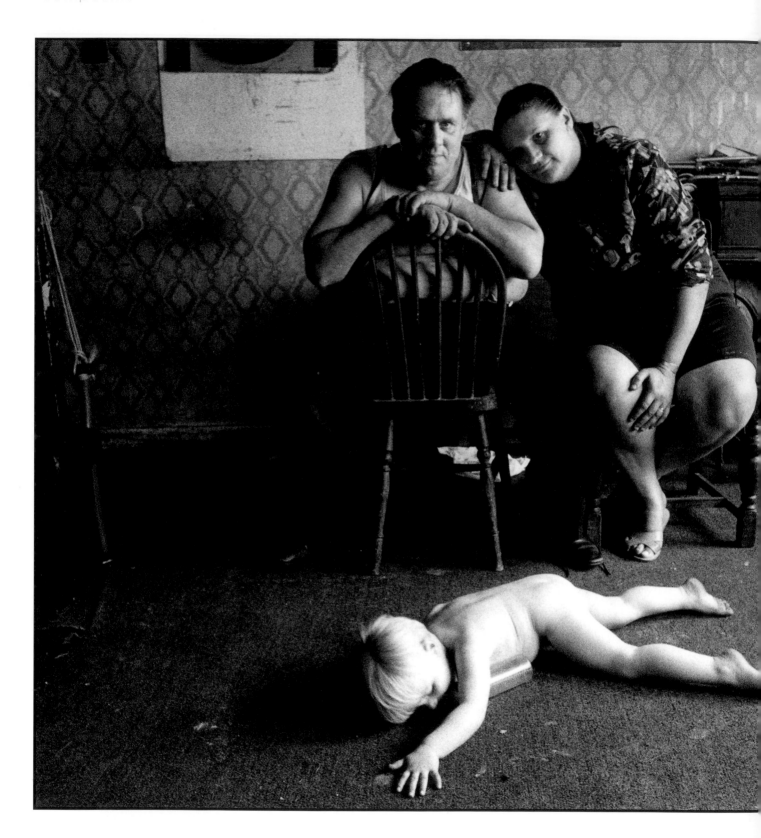

▲ **Uncomfortable feeling**

I find this picture most disturbing. It is part of a story on poverty in Britain; the white, spread shape of the child on the dark floor, separated from the compact composition of the parents, adds greatly to the uncomfortable feeling I have when I look at this picture. This is not a composition that I set up, it just happened and I recorded it. I find some pictures more disturbing when I make the prints than when I am shooting. I think that is because at the time of shooting, the concentration is on getting the picture right — the power then hits you when you see the shot again in the darkroom.

Subliminal messages

When asked what it is about a favorite black-and-white print that makes them feel angry, happy, or sad, most people will tell you it is the subject matter. This is true, but there is usually something else going on. A subtle composition of tonal shapes can heighten the viewer's response to the photograph. We could call this subliminal composition.

An artistically trained eye knows that the composition seduces a certain response, but to the average viewer the composition only exists subliminally. These two pictures have emotional subject matter, but the tonal arrangements finish off the job.

The portrait below of my niece Jo, her husband Stephen, and baby was shot the day after Isaac's arrival. The subject matter appeals to all parents, but it is the subtle composition that gives the picture its cosy feeling. The cradling arms and the touching heads make a circle that looks safe and secure. Composition is not always so dramatic and obvious.

▼ **Cosy feeling of joy**

You can change the mood of a picture with subtle changes. I asked Jo and Steve to put their heads together — but I got lucky with the mother's joyful expression.

28–70mm zoom lens at 40mm; HP5+; 1/250 sec at f/4. Printed on Ilford MGD 1M for 14 secs; f/5.6 at grade 2½. Woman's face held back for 3 secs; man's shirt and backdrop burned in for 6 secs.

28mm lens with tripod; HP4; 1/30 sec at f/8. Printed on Ilford MGFB 1K for 4 secs; f/5.6 at grade 3. Left side held back for 3 secs; right side burned in for 6 secs; baby burned in for 3 secs.

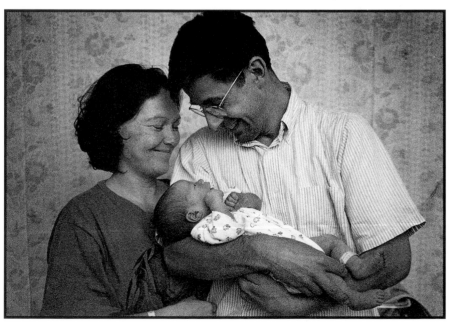

Disturbing images

The great masters of black-and-white cinema, such as Orson Welles and Alfred Hitchcock, used light and shadow to disturbing effect. Often, what could have been a perfectly normal, innocent scene became most disturbing simply by the arrangement of light and shadow on the screen.

Tonal compositions can have the same effect in a photograph — creating anxiety purely through the particular elements in the picture that the photographer has kept in shadow, and those that she or he has left brightly lit.

The black-and-white photograph is capable of lying or, at least, considerable exaggeration.

The image on this page is most probably of an entirely innocent situation. It is a hot summer's day in Hyde Park, London, and a guy has taken a rest from cycling, in the shade of a tree. A young woman is sunbathing in the bright sunlight. In theory, the scene is typical of the restfulness of an English summer.

However, the tonal composition has made this picture rather perturbing. The shadowy figure of the man appears to be ogling the young woman. Evil and innocence are juxtaposed, purely by the tonal contrast. If the man had also been in the sun and brightly lit the picture would appear quite unthreatening — it is his silhouetted figure that has made it disturbing.

▶ **Man and young woman**

The heavy shadow of the cyclist under the tree forms a sharp contrast, literally and metaphorically, with the scantily clad young woman a few yards away. As we can't see the man's expression, we may automatically surmise where he is staring as he smokes his cigarette.

80–200mm zoom lens at 120mm; HP5 rated at ISO 600; $^1/_{500}$ sec at f/11. Straight printed on Ilford MGD 25M for 14 secs; f/5.6 at grade 2.

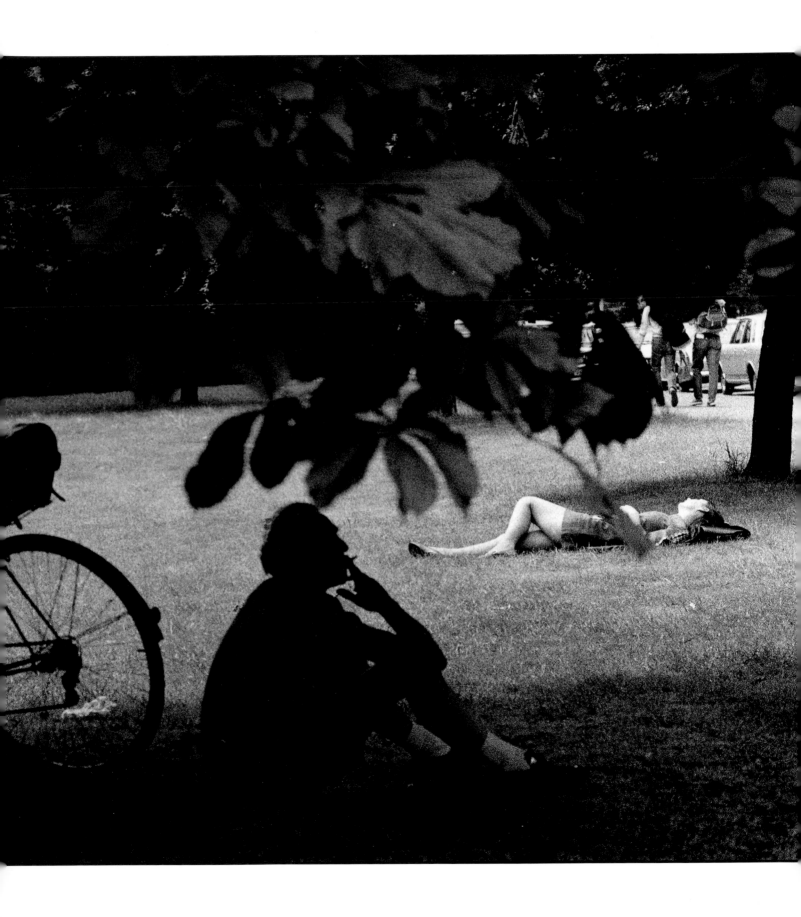

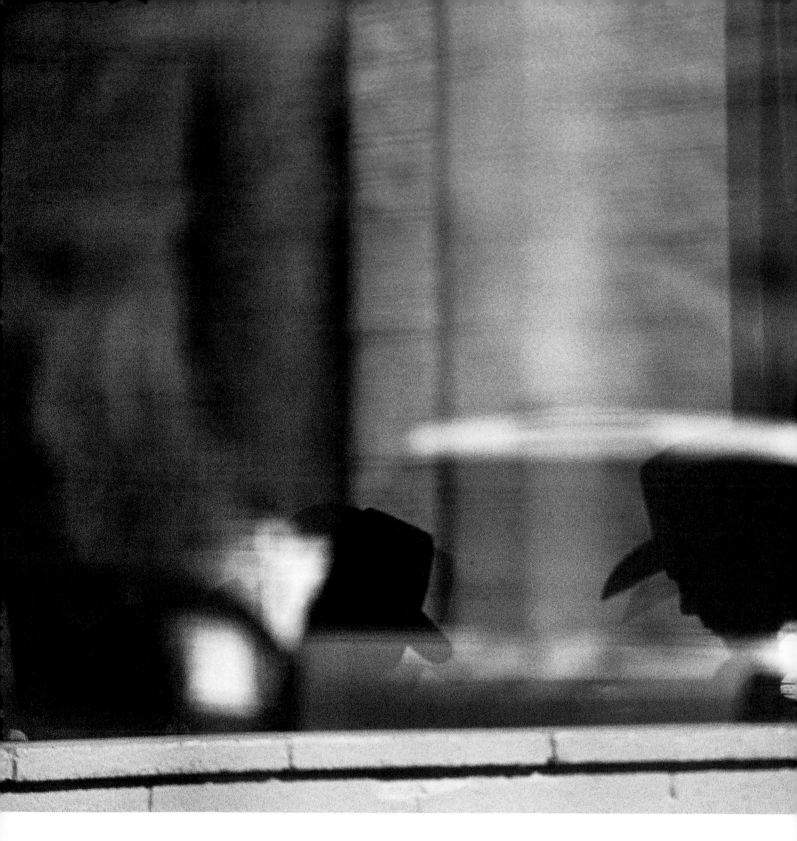

▲ Tonal abstract

Using the simple, iconic Western elements, the mood is captured in an
abstract form.

*35–105mm zoom lens at 80mm; Delta 400; ¹/₅₀₀ sec at f/8. Printed on Ilford
MGD 25M for 14 secs; f/5.6 at grade 3½. Bricks burned in for 8 secs at
grade 1; highlight burned in for 5 secs at grade 1.*

Unlocking patterns

Sometimes you can turn a very ordinary composition into a much more telling one simply by forgetting the "real" subject matter and concentrating on the tones. It is another example of just unlocking the patterns that are all around us. It is not difficult, mysterious, or even arty — you just need to learn to look at life around you as it really is, not as you expect to see it. I like to use abstraction, or semi-abstraction, to create a picture that can be interpreted several ways and mean different things to different people. Sometimes it's nice not to spell it out, but rather have the viewer help write the caption.

I took the small picture of this group of Westerners (below) on my way into a diner in Utah. It is just a snapshot — a record by a foreigner of local folk that look different from those at home. The large picture (left) I took after breakfast, when I noticed the two guys through the window. I was attracted to the tonal patterns their heads made among all the reflections.

By looking at what are basically the same pictorial elements from a different place, I have made a partially abstract image. But it is still unmistakenly taken in the West of the USA.

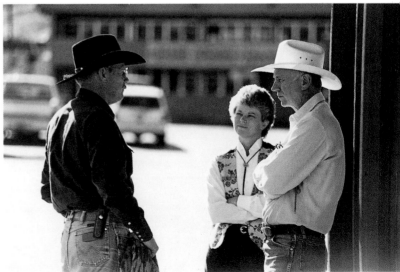

► **Record shot**

The snapshot of these Westerners captures them in their own environment.

80–200mm zoom lens at 200mm; Delta 400; ¹/₁₀₀₀ sec at f/4. Straight printed on Ilford MGD 25M for 10 secs; f/5.6 at grade 3.

Planning a focal point

The focal point is the element in a picture that keeps the eye from running in, through, and out of a picture without taking in the details. The focal point attracts and directs attention to itself. Once there, the eye can then absorb other details in the frame.

I was in the high planes of Colorado, driving down to New Mexico. The fall weather produced stormy clouds on a blue background — perfect! However, in a big landscape like this one, you need a focal point to introduce a sense of scale.

I framed the picture with the road in the bottom third and deliberately left a spot for a car to provide the finishing touch — it was just a matter of waiting for it to arrive. By pre-composing in this way, and just waiting for the car to come along (as you know that it will), you come as close as you can get to "drawing in" your own focal point.

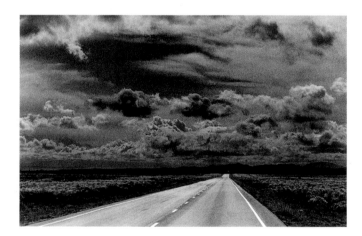

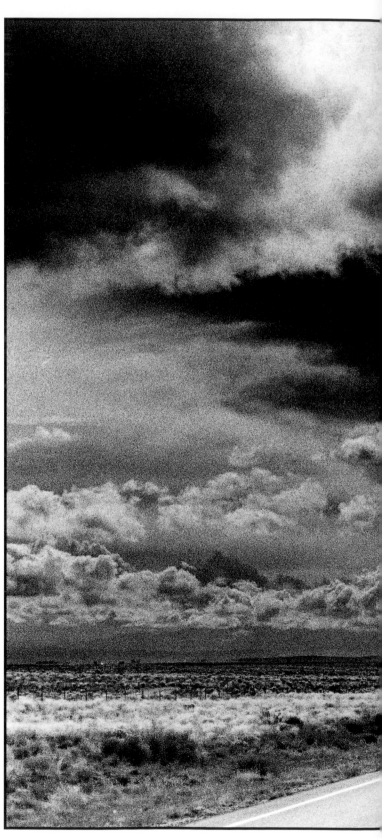

▲ **The scene is set**

The composition is right — but the shot needs a focal point. A red filter increases contrast between the sky and clouds.

80–200mm zoom lens at 110mm; Tri-X; 1/1000 sec at f/11; red filter. Printed on Ilford MGD 25M for 18 secs; f/5.6 at grade 3. Sky burned in for 7 secs.

▶ **Adding the finishing touch**

All I had to do was to wait for the inevitable car to come along the road toward me for the picture to be complete.

80–200mm zoom lens at 110mm; Tri-X; 1/1000 sec at f/11; red filter. Printed on Ilford MGD 25M for 16 secs; f/5.6 at grade 3. Sky burned in for 6 secs at grade 4.

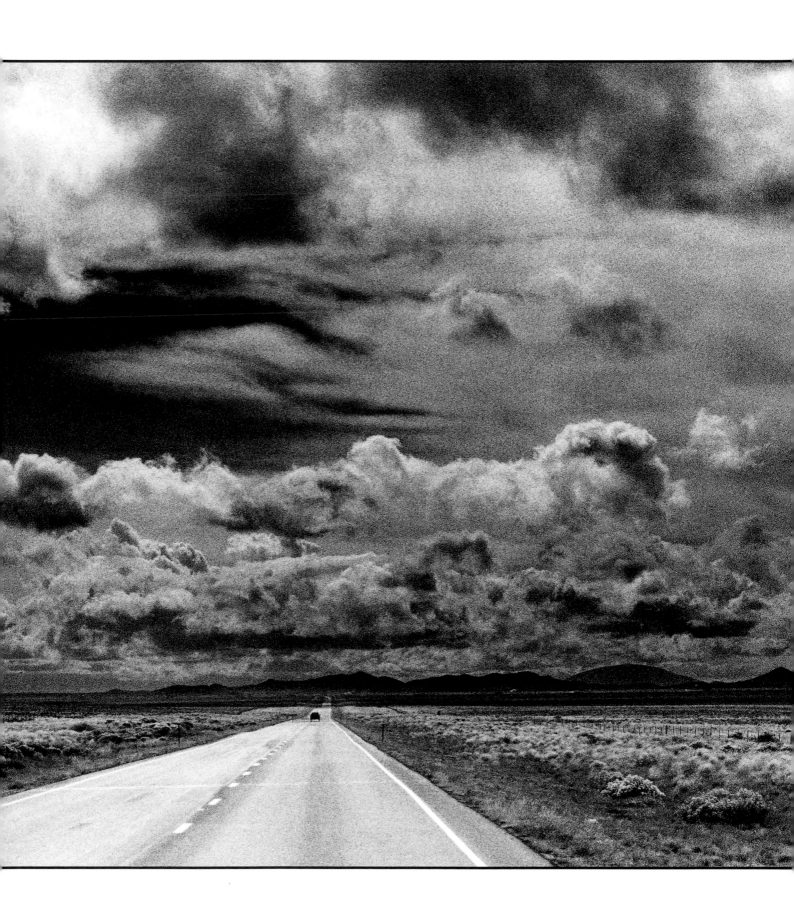

Recognizing a focal point

▶ **Street politics**

In reportage, the focal point of a photograph is captured because the photographer consciously looks for it. The picture here illustrates this point. It shows an intense political discussion on the streets of Belgrade. The pointing finger has caught the light and makes a focal point against the dark gray of the overcoats. This composition couldn't be planned, but, being aware of the need for a point of interest, I could press the button at the right moment.

35–105mm zoom lens at 105mm; HP5 rated at ISO 600; ¹/₃₅₀ sec at f/5.6. Printed on Forte Warmtone FB for 22 secs; f/5.6. Hand burned in for 7 secs; faces shaded for 3 secs.

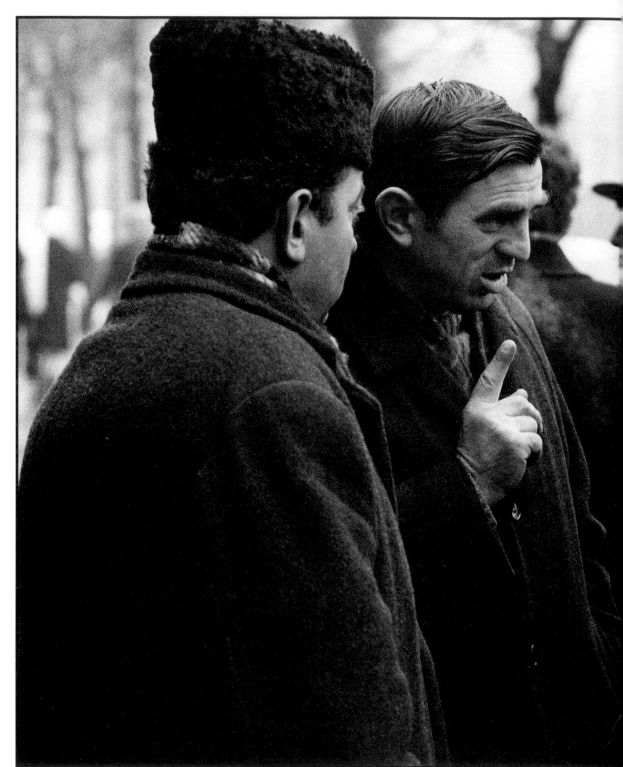

Technically speaking, the focal point is the spot on which you focus in the frame. However, the term has come to be used to describe the point that is the focal interest of a picture — it is the object that draws the eye, that holds the viewer's attention, and around which everything else in the composition is built.

Although focal point is a much-discussed topic in photography, I make no apology for giving the subject great emphasis. A focal point is very, very important. In fact, it is the missing element from many rather nice pictures that could have been superb. So often I have looked at a great vista and thought, "If only there was a little, white farmhouse just off-center to the left, this would be a superb landscape!"

With black-and-white composition, finding a focal point is frequently more difficult than with color film. The object alone is not good enough — it must be of the right tone. It should contrast tonally with its background, so that it leaps out of the print. It should therefore be of a light tone if the background is dark, or a dark tone if the background is light — a light tone set in a dark background, or vice versa.

Set-ups

Many compositions that appear to be spontaneous reportage are, in fact, pre-planned. I often find a situation, or a pattern of tones and shapes, that would make a good picture if only it had that vital element. The missing ingredient is usually people, who give the scene that special edge or emotional drama.

What I do is compose the shot, leaving a spot for the absent element. As soon as the spot is filled I push the button — and, hey presto, the composition is complete! Look around for these situations — advertising billboards, in particular, make a very different statement from that originally planned by the advertisers when juxtaposed with pedestrians.

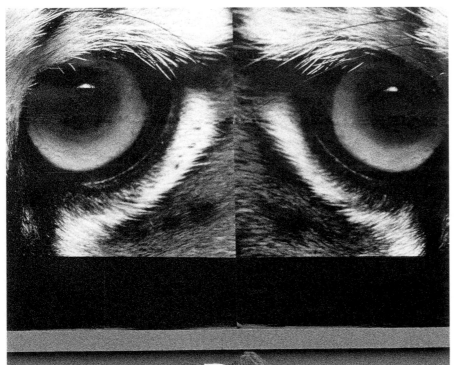

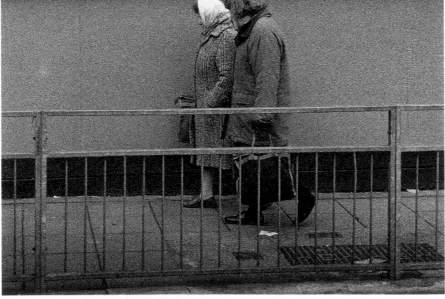

◄ **You are being watched!**

The two eyes are from two posters, which looked bizarrely amusing. I waited until the two old ladies walked under the waiting tiger — and shot the picture.

80–200mm zoom lens at 100mm; T-Max P3200; ¹/₅₀₀ sec at f/11. Printed on Ilford MGD 25M for 14 secs; f/5.6 at grade 3. Area above tiger's eyes burned in for 3 secs.

► **Silhouette in Siena**

I was attracted to the light and shade around the posters. The passers-by were in shadow, creating strong, graphic shapes. I waited until this old lady came by and filled my pre-composed spot.

28–70mm zoom lens at 28mm; HP5; ¹/₅₀₀ sec at f/8–f/11. Printed on Ilford MGW 1K for 17 secs; f/4–f/5.6 at grade 3. Shadow left and bottom held back for 5 secs.

Catching movement

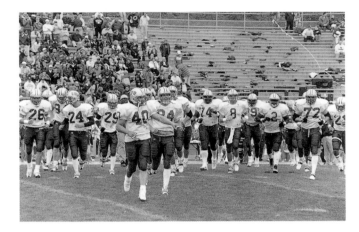

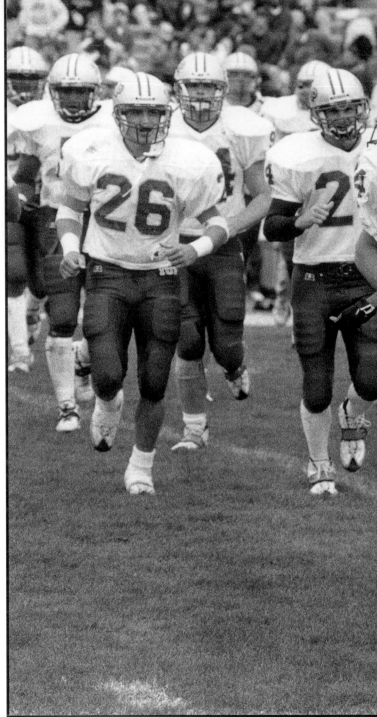

Composition of black-and-white action pictures comes down to an ability to recognize a good example as it develops. I try not to get too involved in searching for facial expressions, and so on, but rather concentrate on the shape of the action as a whole. This helps me to shoot as I sense the shapes coming to form a strong composition. Experience has taught me that with most action pictures the facial expressions will be dramatic anyway.

You should anticipate and plan as much as possible, then watch the shapes in the viewfinder. You then press the shutter as the tonal shapes are forming strongly, but you must shoot before the composition is completely right. You need to see the picture in advance and be pushing the button before the action peaks. They say that if you see a great action picture in the viewfinder, it is already too late — you've missed it! You can't chase a beautiful composition, you have to be there and let it come to you.

Here, I was watching a college football game and knew that the tonal contrasts in the uniforms would make a good black-and-white shot. I decided to take a shot as the players ran off for halftime. It was then a question of positioning myself where I could get a clear view, and waiting for the right moment.

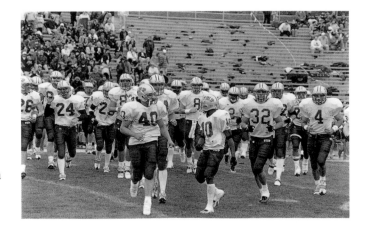

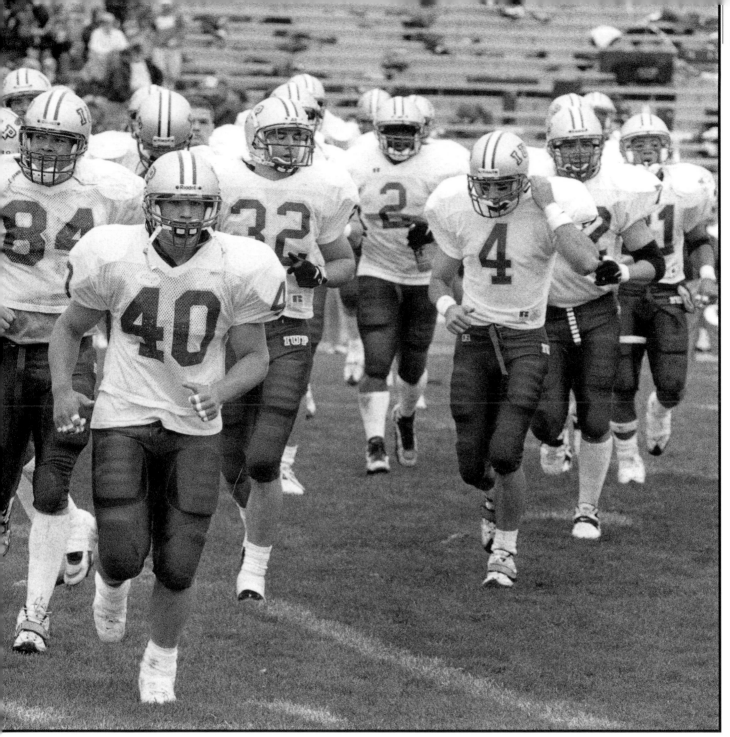

◄◄ **My first attempts**

The players are beginning to group into a visible formation (above left) with a central focal point, but the composition is ragged and not particularly dramatic. As they move (left), the formation tightens and begins to form into a visible V-shape, giving me a more defined composition.

80–200mm zoom lens at 200mm; T-Max P3200; ¹/₃₅₀ sec at f/11. Printed on Ilford MGW 1K for 12 secs; f/5.6 at grade 2½.

▲ **Caught it!**

Once the quarterback moved into the center of the frame, the picture had to be taken. As soon as I had the film processed and was looking through the contact prints, I knew I was looking for one frame. From a graphic point of view, it is pleasing; from a sports-photography viewpoint, it turns the players from a bunch of guys into a team.

80–200mm zoom lens at 200mm; T-Max P3200; ¹/₃₅₀ sec at f/11. Printed on Ilford MGW 1K for 12 secs; f/5.6 at grade 2½. Grass in the V-shape and legs burned in for 4 secs.

Recognizing tension

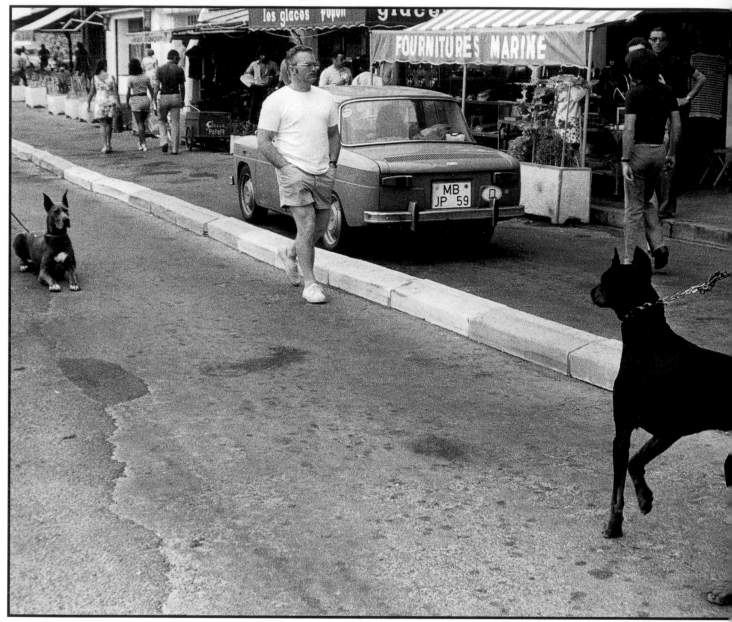

We mostly think of tension in a photograph as coming from the content. The tough war photograph or the high-octane sports shot are obvious examples of where the subject matter can produce tense pictures.

But it is also the composition that adds to the tension of a photograph and sometimes is totally responsible for the drama and conflict created.

As photographers, we are trying to tell a story — to make people care about the things we have been photographing. This is the case whether the photograph is for a fashion advertisement or reportage of a famine in the third world.

It is insufficient just to record the subject, however much built-in drama it has. We must compose the picture to milk all its intensity.

The viewer of a picture is as emotionally affected by the tonal composition of a black-and-white photograph as by the content. It's not just the story that counts, but the way that you tell it.

◀ Canine conflict

The tension created by the composition is far greater in the main picture. The owners are cropped out, leaving the dogs to dominate the space. The dogs are dark, threatening, positive shapes in combative stance. The most important compositional feature is the line of light-toned paving stones that sweeps the eye diagonally across the frame from the standing dog to the crouching dog.

35–105mm zoom lens at 35mm; HP4; 1/500 sec at f/5.6–f/8. Printed on Ilford MGW 1K for 16 secs; f/5.6 at grade 3. Left-hand third of the picture burned in for 3 secs.

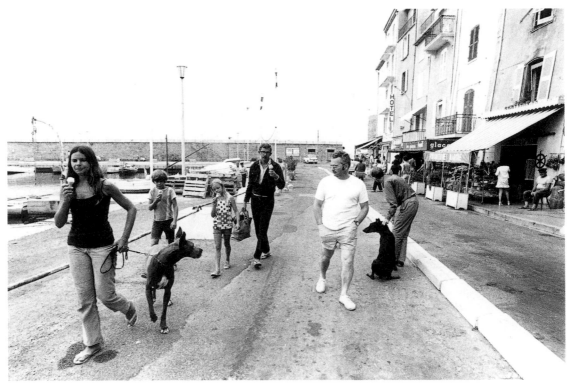

▲ Distractions spoil drama

The first attempt has the ingredients for a strong picture — two dogs with attitude — but the people between the dogs have reduced the graphic tension. The white shape of the man in shorts is particularly distracting, as it interferes with the line of sight between the animals.

35–105mm zoom lens at 35mm; HP4; 1/500 sec at f/5.6–f/8. Straight printed on Ilford MGW 1K for 15 secs; f/5.6 at grade 3.

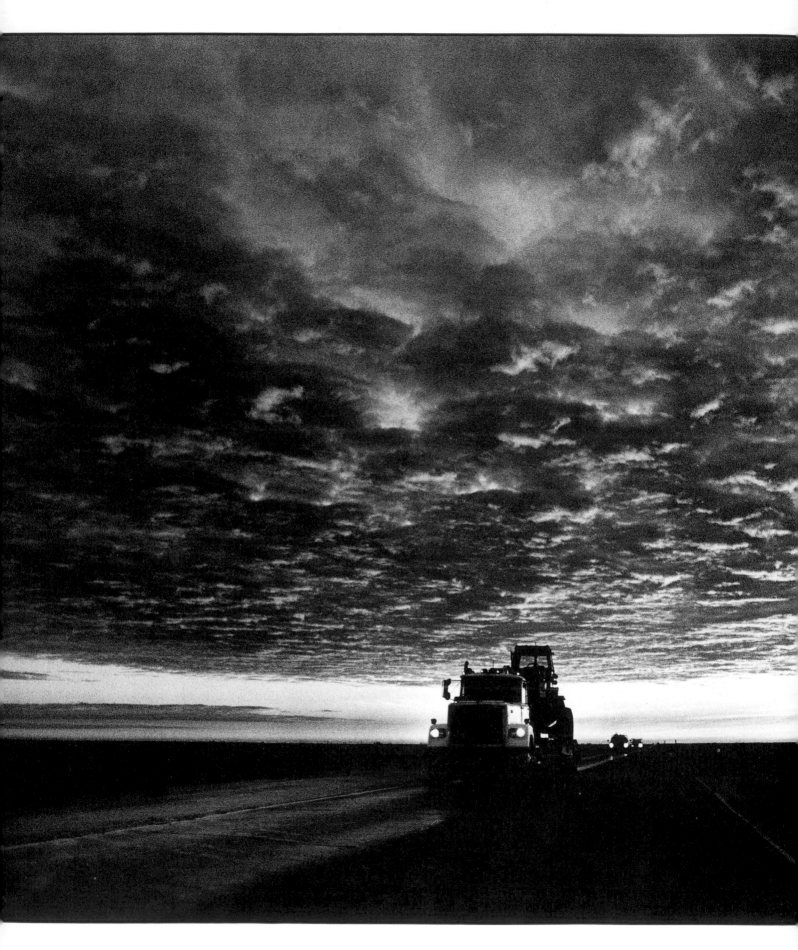

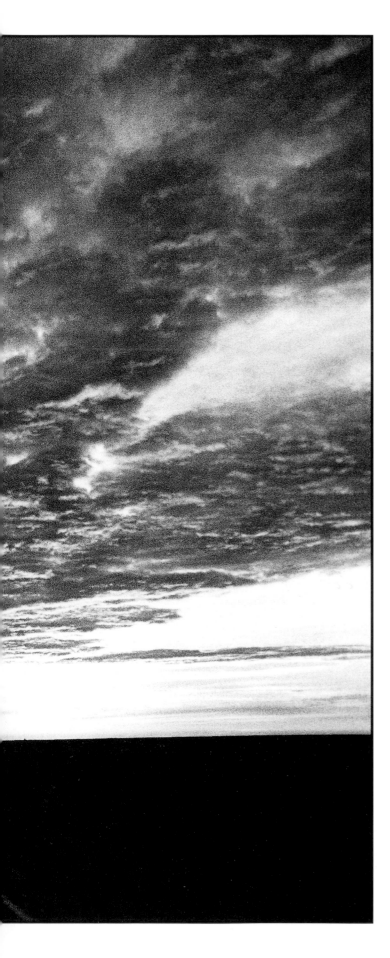

Handling light

◁ Dawn on Route 87, Texas

This is a picture usually shot in color, with pink clouds and so on. I was not really sure how the picture would work in black and white. I used a tripod and waited for the truck to give me scale and a focal point. I used an orange filter which has given good contrast between the pink and the gray of the sky.

24mm lens; T-Max 100; ¹/₁₂₅ sec at f/8. Printed on Ilford MGW 1K for 22 secs; f/5.6 at grade 3¹/₂. Sky burned in for 8 secs, road held back for 5 secs.

Early morning

Early morning provides the classic landscape photography light. It is similar to late afternoon light, but it is sharper and cleaner, because the dust and pollution of the day have not yet taken effect.

This light provides such great molding and definition to go with the shadow and highlight patterns. I always bracket exposures, as it is hard to decide at the time how much detail you want in the shadows.

Early-morning light is magic! People are interesting at this time of day, too, as you and they share an affinity — all enjoying the best part of the day while everyone else is still in bed. I am seldom disappointed by an early-morning shoot — everybody and everything looks scrubbed clean and sharp by the early light. There's always a good picture to compensate for the early start!

▼ **The tree**

The early-morning light is clear and the definition is sharp.

50mm lens with orange filter; HP5+; 1/250 sec at f/11. Printed on Ilford MGW 1K for 15 secs; f/4–f.5.6 at grade 2½. Tree trunk held back for 4 secs.

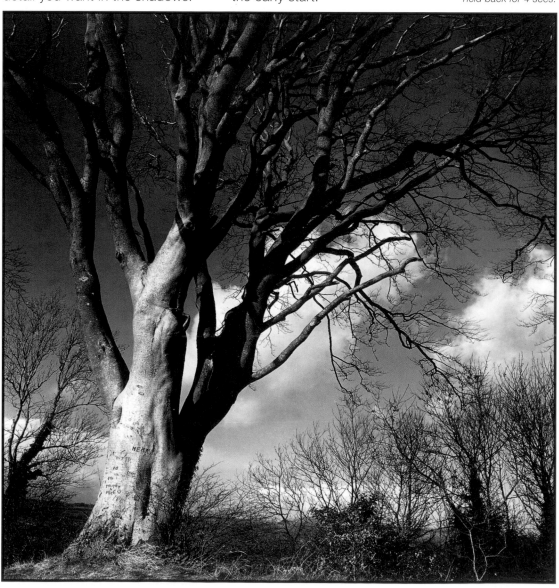

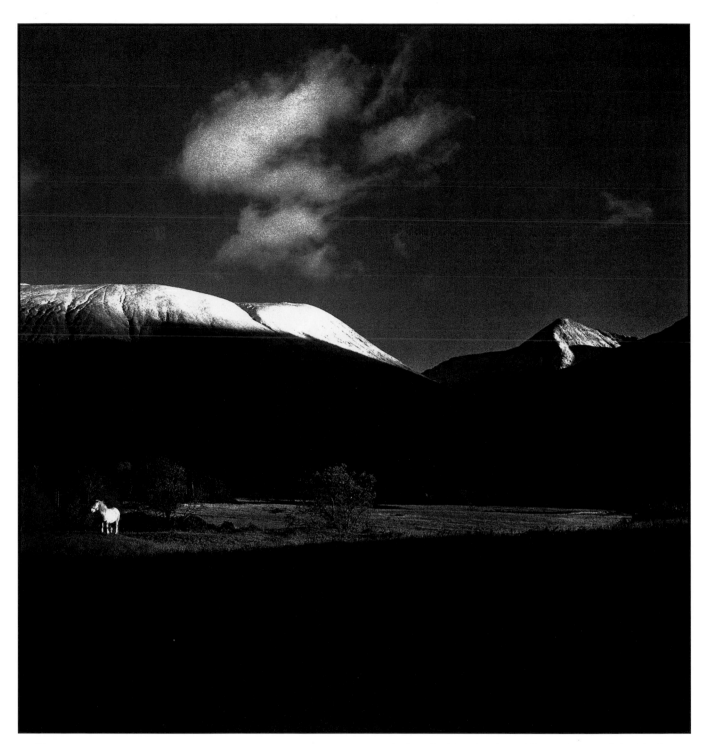

▲ Glencoe

I shot this in the Scottish Highlands, before the sun rose. I had seen the picture's potential the day before and roughly worked out with my compass where the light would be the next morning. I always bracket exposures in these situations. I produced negatives with lots of shadow detail, but preferred a more dramatic, black-shadow area when I came to make the print. Note that the red filter has increased the already apparent contrast.

50mm lens with red filter; HP5+; 1/125 sec at f/11. Printed on Ilford MGW 1K for 25 secs; f/5.6 at grade 3. Horse, cloud, and shore bleached with weak bleach solution.

Window light's virtues

Window light was the only interior light source for centuries, and it is just as useful these days as it was for the great painters of yesteryear. The most important consideration is to allow for long exposures. Don't be put off by what seems to be low light.

Just use a longer shutter speed — and a tripod.

Dim window light produces beautiful negatives because shadows tend to gain detail without overexposing the highlights. With exposures of over 2 seconds, negatives soften out.

Window light is a great favorite for still-life photographers. In fact, most studio pictures are lit by diffused flash units that are designed to reproduce the look of a window light (flash is used, as it is easier to maintain accurate color balance with color film).

▶ **The masks**

Taken in the Royal Ballet's make-up studio. The light is 45 degrees above the subject and has provided very good modeling.

35mm lens; HP5+; ¹/₉₀ sec at f/8. Printed on Forte Warmtone FB for 15 secs; f/5.6.

▲ **Classic use of window light**

My son Nick's face is three-quarters to the window; no reflectors, hence the strong shadow.

80–200mm zoom lens at 130mm; T-Max 3200; ¹/₂₅₀ sec at f/2.8. Printed on Forte Warmtone FB for 23 secs; f/5.6.

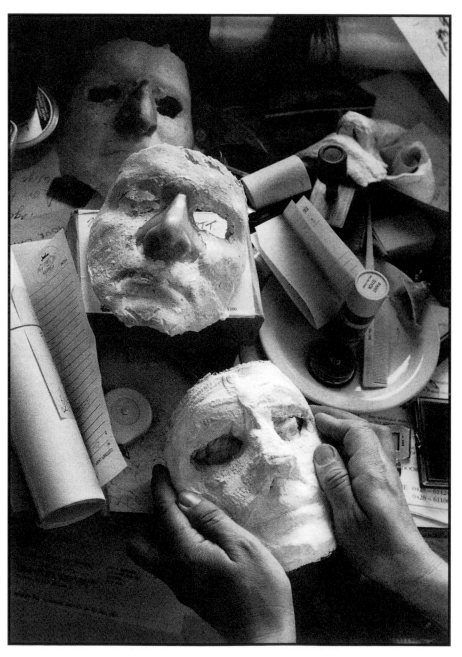

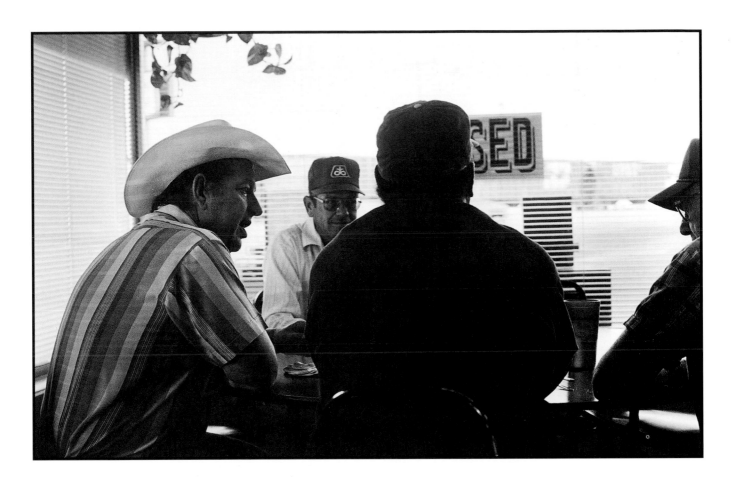

▷ Romantic light

For this portrait of
star ballerina Viviane
Durante, I used a
high window light as
a backlight, with a
reflector bouncing
the light back into the
face. The backlight
has haloed her hair,
and the bounce-fill
has provided soft
light for the face.

*135mm lens; HP5+;
¹/₅₀₀ sec at f/2.8.
Printed on Kentmere
Art Classic for 18
secs; f/5.6. Clothes
burned in for 6 secs;
background burned in
for 20 secs.*

▲ Texan diner

I used the bright
window light for a
semi-silhouette —
compromising on
exposure to get
some detail outside
and in the backlit
faces. I over-
exposed one stop
and used fill-in flash.

*35mm lens; Tri-X;
¹/₅₀₀ sec at f/5.6.
Printed on Ilford
MGW 1K for 19 secs;
f/8 at grade 3¹/₂. Left-
side shirt and wall
burned in for 8 secs;
second face held
back for 3 secs;
window area burned
in for 10 secs.*

Benefits of backlighting

Most subjects are flattered by backlight. The effect can be stunning, but it can be quite tricky to shoot with in black and white. The main problem is exposure.

Because light pours straight into the camera's metering system or hand meter, you underexpose the subject because the meter is trying to produce correct exposure. The normal formula is to overexpose by 1½ stops, but 2 stops is safer. Use a spot meter system or get closer to the subject so that it fills the frame in order to get an accurate reading. (If you are unable to get closer, select an area that has the same tonal values as the subject and read off that.)

The classic method of using backlight is with a fill light from the camera. Fill-in flash or reflectors are used equally effectively, but I prefer reflectors as I can see what I'm doing. I use flash-fill when I can't support the reflector. When shooting large, backlit subjects, bracket your exposures to ensure you don't end up with a silhouette.

◄ **Percy Cerrutti**
Cerrutti (a famous athletics coach) is three-quarter backlit by bright sunlight. Large sand dunes behind me acted as a huge reflector, providing perfectly balanced fill light. *Rolleiflex 80mm lens; FP4; approx. ¹/₂₅₀ sec at f/8. Printed on Forte Warmtone FB for 20 secs; f/5.6 at grade 3. Print flashed in developer.*

▶ **Rim lighting**
Soft backlight is diffused through light cloud cover. *80–200mm zoom at 180mm; HP5 rated ISO 600; ¹/₁₀₀₀ sec at f/4. Printed on Ilford MGD 25M for 14 secs; f/5.6 at grade 3. Figures held back for 4 secs; can burned in for 5 secs at grade 1½.*

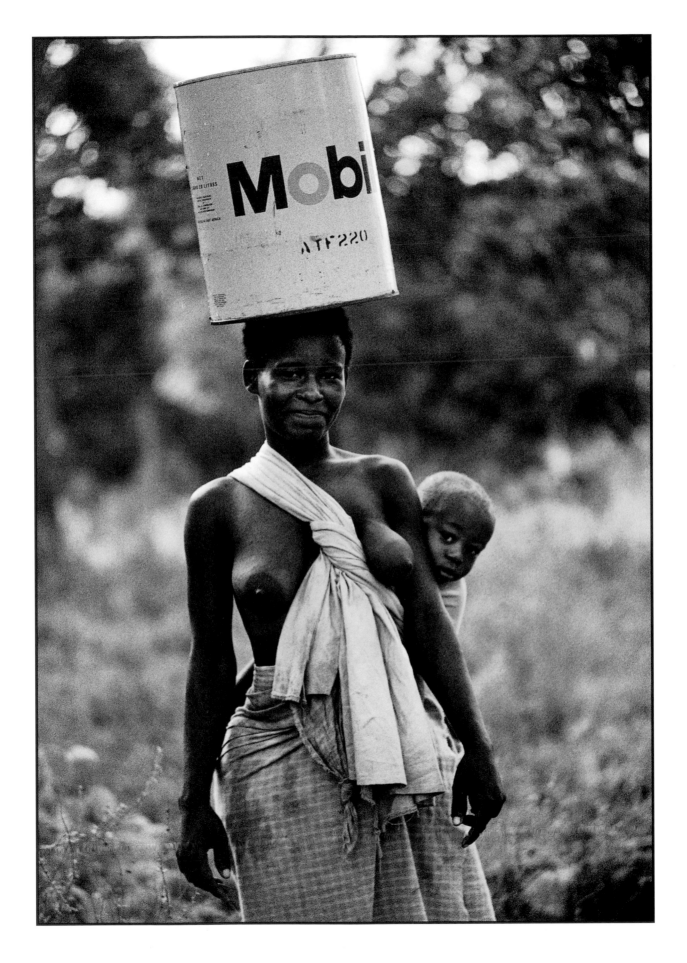

Hard light challenge

Hard light is how photographers describe light that produces bright highlights and almost black shadows. Many black-and-white photographers avoid this lighting situation, because they want to reproduce a full range of tones in their print; hard light makes this impossible. But if you think of using it as a friend rather than an enemy, it is a great light source for making very stark, graphic images. When you are confronted with hard light, forget about trying for shadow detail and just expose for the highlights to give a graphic look.

▲ **First posed shot**

I spotted this young man when I was travelling in the high plains country near Moab, Utah, on an incredibly bright, sunny day. I felt he would make a good subject for a portrait that was a "symbol" for the trip, but was concerned initially about the degree of contrast. To avoid the problem, I took this first photograph in the shade, but it lacked impact.

80–200mm zoom lens at 150mm; T-Max 100; ¹/₅₀₀ sec at f/8. Straight printed on Ilford MGW 1K for 12 secs; f/5.6 at grade 3.

▲ **Into strong light**

We moved out into the sun, and I began to use the hard shadows creatively. This shot is my first uncontrolled snapshot in these very bright conditions, but I liked the way the shadows strengthened the composition.

80–200mm zoom lens at 150mm; T-Max 100; ¹/₅₀₀ sec at f/8–f/11. Straight printed on Ilford MGW 1K for 12 secs; f/5.6 at grade 3.

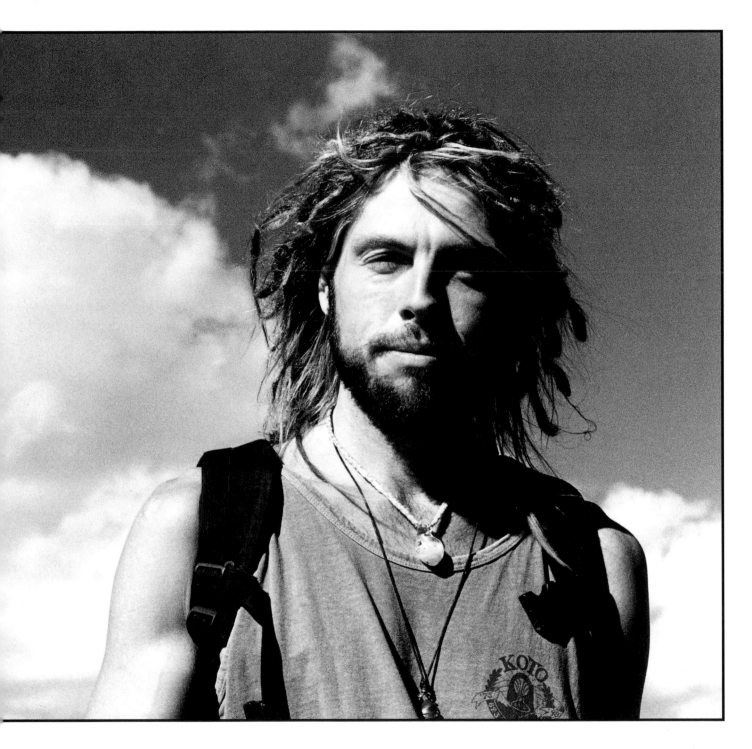

▲ **Against the sky**

Eventually, by positioning the subject against the clouds to add drama, I used the harsh light to my advantage to create a portrait with strength and character. An orange filter has lightened the tones of his face and simultaneously darkened the sky. The lower camera angle makes him look heroic — his enigmatic expression is appropriate for a traveller whose destination and purpose are unknown.

80–200mm zoom at 90mm; T-Max 100; 1/500 sec at f/8. Printed on Ilford MGW 1K for 16 secs; f/5.6 at grade 3. Figure shaded for 4 secs.

Poor light

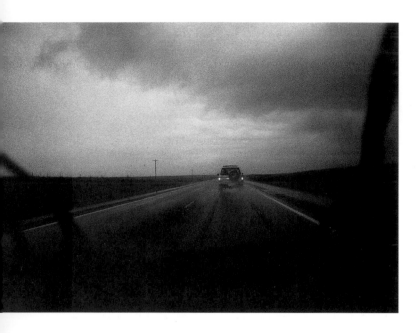

◁ **Washout**

This was my first attempt, and something of a failure!

24mm lens; T-Max P3200; ¹/₂₅₀ sec at f/5.6. Printed on Ilford MGW 1K for 12 secs; f/5.6 at grade 3¹/₂.

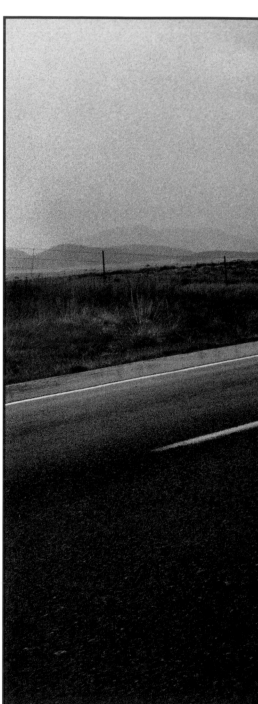

Don't let poor light deter you. I believe there are very few conditions in which you cannot produce an interesting black-and-white image, if you look at the world through a different perspective. I was driving back east through Colorado in terrible weather — dark and wet all day. In frustration, I started shooting through the windshield. At about 5:00pm, I noticed the sun breaking through in the west in the driver's-side mirror, stopped, and took some shots. The mirror picture is something of a photographic cliché — but clichés become clichés because they work.

◁ **No improvement**

A different composition, but the light is worse.
24mm lens; T-Max P3200; ¹/₂₅₀ sec at f/4. Printed on Ilford MGW 1K for 12 secs; f/5.6 at grade 3¹/₂.

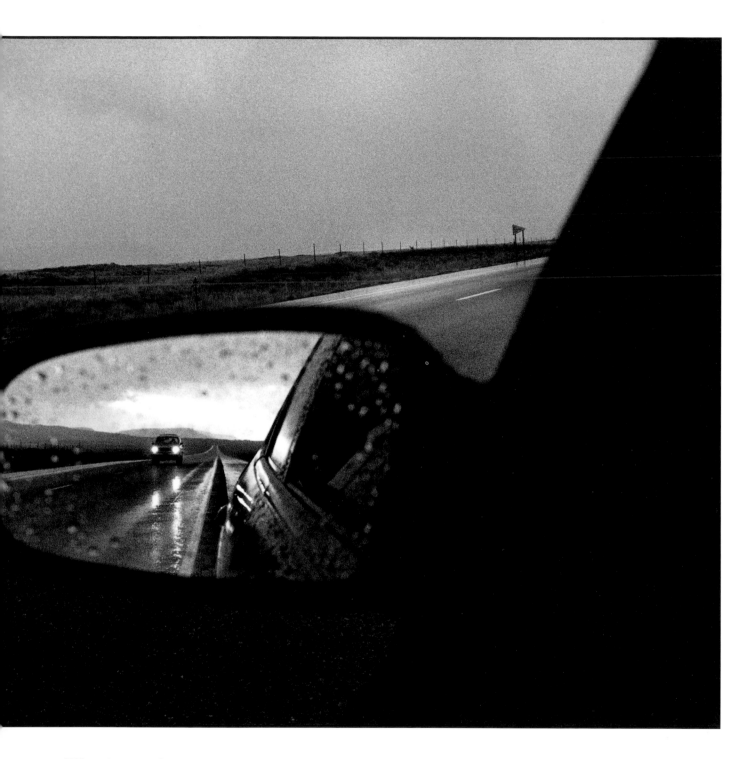

▲ Different perspective

I shot through the side mirror, taking advantage of the sun breaking through the clouds. With experience, photographers grow a light meter in their heads, and I am very sensitive to the smallest light change, which can often make the difference between success and failure.

·24mm lens; T-Max P3200; ¹/₂₅₀ sec at f/4. Printed on Forte Warmtone FB for 15 secs; f/5.6 at grade 3¹/₂. Grass down left-hand side shaded for 4 secs; car in mirror burned in for 4 secs.

High key/low key

▼ **High key**

250mm lens on Hasselblad with flash;
FP4 rated at ISO 100; synched at f/8. Printed
on Ilford MGW 1K for 12 secs; f/5.6 at grade
4. Eyes held back for 2 secs; area under nose
held back for 3 secs.

High key describes a print that consists mainly of light tones, and is an effect usually used to produce flattering portraits.

Creating high-key portraits requires planning. The backdrop needs to be white, the lighting needs to be a frontal flood with as large a spread as possible, and the subject needs to be bare-shouldered or wearing a white top. I always make sure that I get a dense negative that is easy to print light by overexposing by 1 stop.

On location, in daylight, I use backlight and reflect it back into

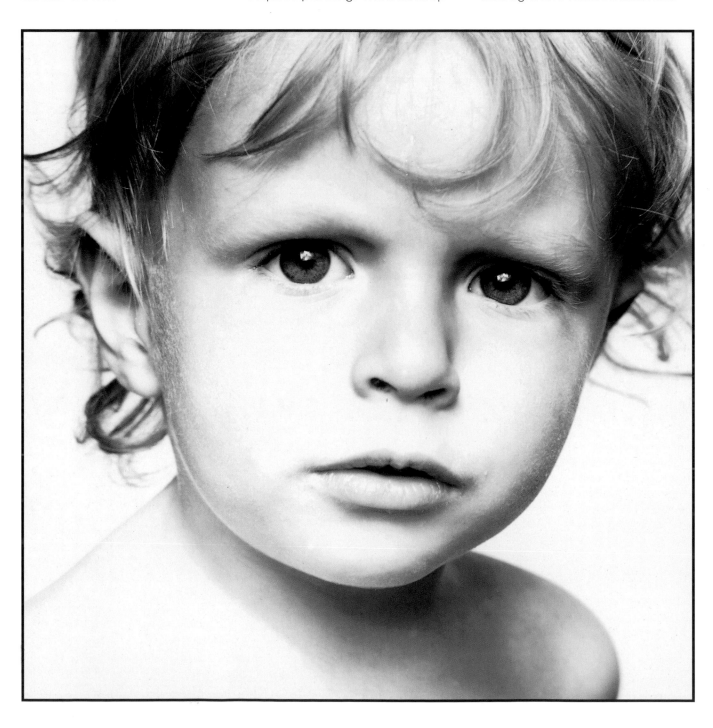

the face with a reflector. I use an orange or red filter to illuminate the mid-tones and clean up any possible skin blemishes.

Low key describes a print that is mainly dark and rich in tone. When setting out to create a low-key portrait in the studio, use a black background, dress the subject in a black top, and light him or her with a good deal of shadow.

Traditionally, portraitists used a blue filter to strengthen the skin tones and facial details, but this also accentuates skin blemishes. You can print a very satisfactory low-key image without it, by being careful not to overexpose or overdevelop the negative.

▼ **Low key**

150mm lens on Hasselblad with flash; FP4 rated at ISO 100; 1/60 sec at f/5.6. Printed on Ilford MGW 1K for 20 secs; f/5.6 at grade 3. Eyes held back for 4 secs; corners of print burned in for 5 secs.

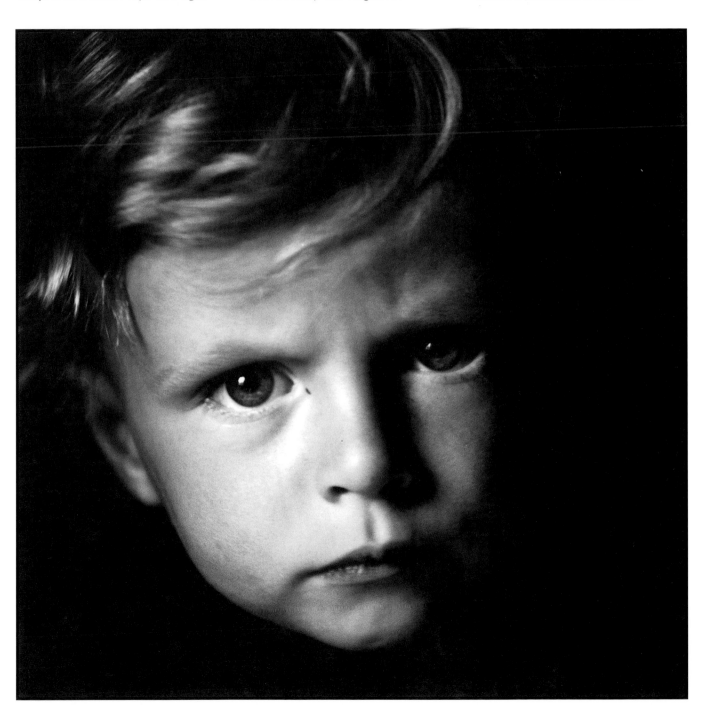

Nature's spotlight

Nature's spotlight is the term I give to that spotlight quality that God throws out occasionally — on His better days.

It is the pre-sunset light that you get in the tropics, the shaft of light that bursts through thick clouds and spots a farmhouse, and the post-rainstorm light that spots a rock formation and usually throws in a rainbow effect.

I have selected examples of nature's spotlight to underline just how important quality of light is to black-and-white photography, and how a drop of magic light can transform an ordinary subject into a strong picture. Light is only magic if the photographer can visualize its effect on the final print.

The spotlight effect that natural light produces is usually fleeting, and you need to work fast or it will fade away before you can load the camera. Whenever possible, bracket the exposures to be sure of a versatile negative. So this is the place for the most obvious tip of all, yet one we all need to be reminded of: never put away your camera unloaded. In addition, always be prepared to react fast to an exciting lighting effect. I have taken to wearing a photographer's waistcoat when on location, which allows me to keep any filters and film and two extra lenses on my person. I may look silly, but that's a fair price to pay for being ready for the old spotlight.

▼ **Mission Beach, Queensland**

The girl is lit through the palm trees, but it looks more like flash than natural light. 35–70mm zoom lens at 65mm; HP5+ rated at ISO 600; ¹/₅₀₀ sec at f/5.6; orange filter. Printed on Ilford MGW 1K for 17 secs; f/5.6 at grade 3. Boat burned in for 20 secs at grade 1¹/₂; legs burned in for 4 secs at grade 3; shirt burned in for 4 secs at grade 1¹/₂.

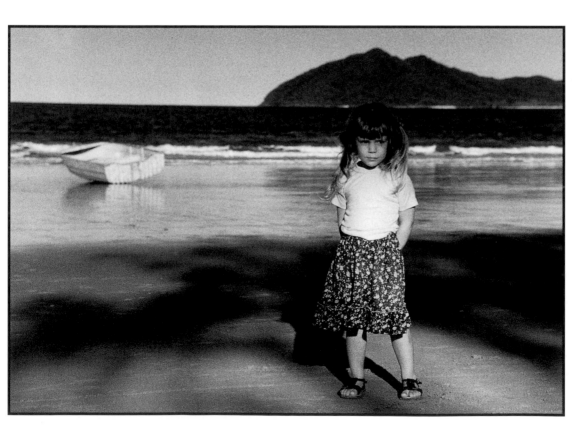

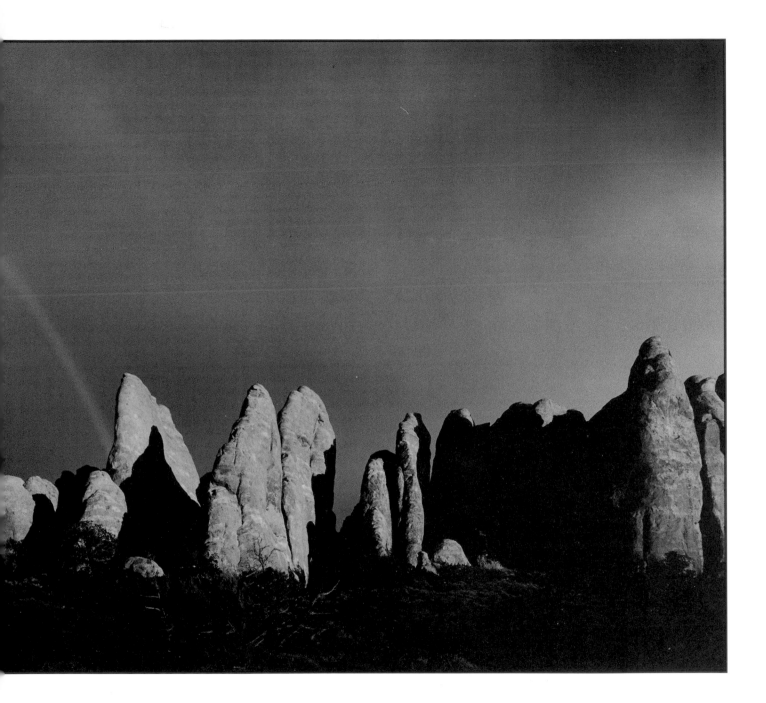

▲ The rainbow

Just after a rainstorm, near Moab, Utah, I found this classic landscape lighting situation. The sun often smashes through a cloudbank and spotlights the countryside, producing brightly lit subjects against almost black skies. Sometimes God throws in a rainbow, as well, if you have been very good. Note that I very lightly bleached back the rainbow, using a weak bleach solution and a cotton swab.

35–105mm zoom lens at 90mm; Delta 100 rated at ISO 80; 1/250 sec at f/8. Printed on Ilford MGW 1K for 15 secs; f/5.6 at grade 3½. Foreground burned in for 15 secs; top right-hand corner burned in for 5 secs; highlights burned in for 4 secs; rainbow bleached with weak solution.

Available light

Available light is an all-embracing term that describes all interior, low-light situations. Available light is particularly suited to black and white because mixed light sources, such as daylight with tungsten, make color photography a precarious business. Without a color temperature meter, you will find it is impossible to visualize the color balance.

As flashguns have improved, with the control that is now possible using dedicated strobe units, many photographers have stopped looking at available-light situations, and instead reach for the flash. This is a pity, as it kills so many dramatic lighting situations.

As films become faster, available-light photography has become easier. Available-light pictures were often difficult to print because of the harsh contrast and lack of shadow detail created when you push-develop black-and-white film.

However, the latest fast films can be pushed to incredible speeds (see pp 28–29), while retaining excellent shadow detail, without highlights burning out. There are now few situations that require flash because the light is too low.

▶ **Scuba bather**

This picture would normally be shot with flash nowadays. It is of my youngest son (now 22) stepping from the bath. The light from a single bulb is quite sufficient, and in fact makes a strong lighting effect.

35mm lens; HP5; $^{1}/_{125}$ sec at f/2. Printed on Ilford MGW 1K for 16 secs; f/5.6 at grade 3½. Bath burned in for 6 secs at grade 1½.

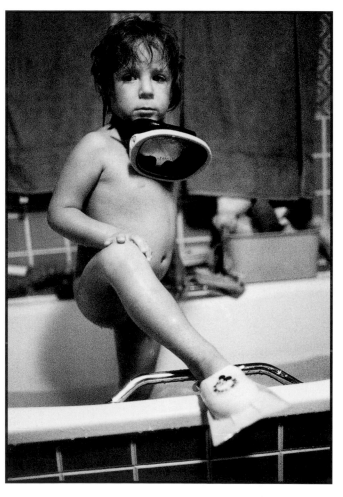

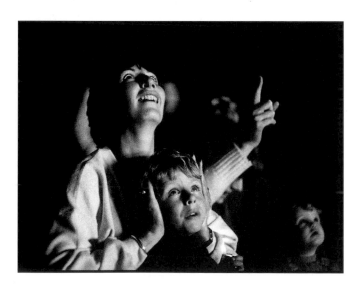

▲ **My wife, Michelle, and son, Nick, on bonfire night**

Although there are large black areas everywhere, the faces are very well-lit by the light of the bonfire. The whole atmosphere of this picture is created by the glow of the fire; this would be completely lost with flash.

50mm lens; HP5; $^{1}/_{125}$ sec at f/2.8. Printed on Ilford MGD 1M for 11 secs; f/5.6 at grade 3. Background faces burned in for 10 secs at grade 1.

▶ **Clowns backstage**

Shot on the older generation of fast film, but still better than using flash! *28mm lens; Kodak 2475 rated at ISO 1600; $^{1}/_{30}$ sec at f/5.6. Printed on Ilford MGW 1K for 20 secs; f/5.6 at grade 4.*

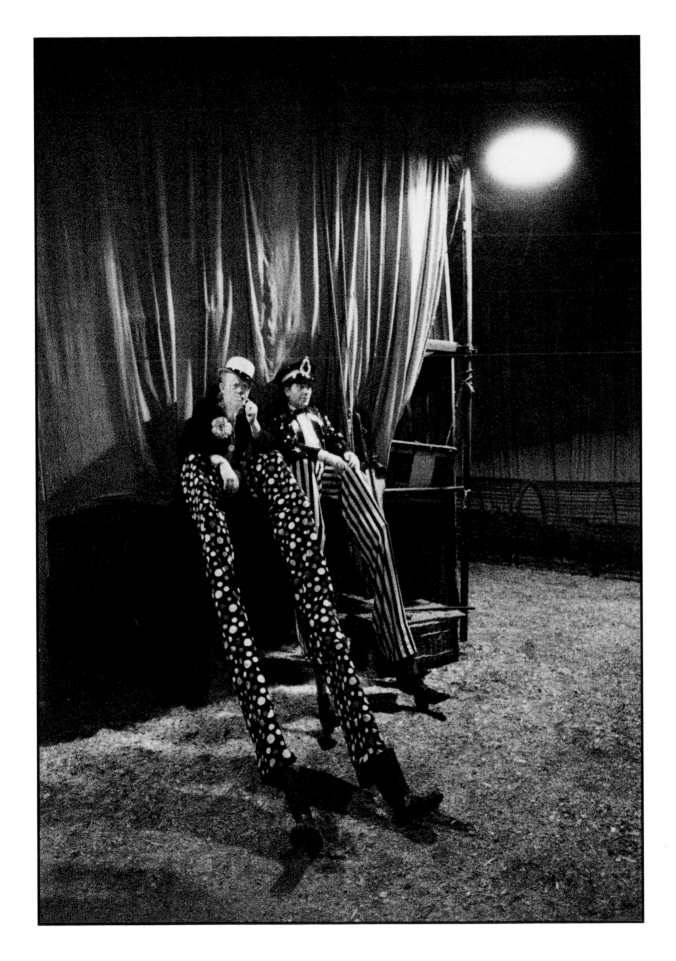

Natural light with flash

Although I don't consider flash as a light source to use when the available light is getting low, it is a superb light source with its own qualities, and is far more than a desperation measure.

Hand-held flash has evolved enormously in the last few years. All the leading camera manufacturers have dedicated flash units that will provide auto-exposure, auto-fill, auto-bounce, and so on. As long as you can remember which buttons to press, they can guarantee correctly exposed pictures effortlessly.

(I must admit that I have a list reminding me of the buttons for functions stuck on the top of my Nikon flash unit.)

I like to use a flash to alter the existing lighting balance, changing the tonal relationships between the subject and the background. In my earlier days this required a quite tricky calculation, but now the flashgun does it for me — technology can be great! I also use my flash as a fill on backlit portraits when using a reflector is impractical. The examples shown here are very typical of these uses.

▼ **Pigeon fancier, Durham, England**

The prevailing light conditions were dull and flat. I decided to use flash to kick the miner and his pigeon out from the background, while leaving some detail behind. I held the flash above my head with my left hand and worked the camera with my right. The camera was set at -⅔ stop, as I thought the face and pigeon just needed to be clean, light tones against a somber, dark background. The picture is from a series on a mining village.

28–70mm lens at 32mm with flash; HP5+; ¹/₁₂₅ sec at f/5.6–f/8. Printed on Ilford MGW 1K for 16 secs; f/5.6 at grade 3. Hands and bird burned in for 6 secs.

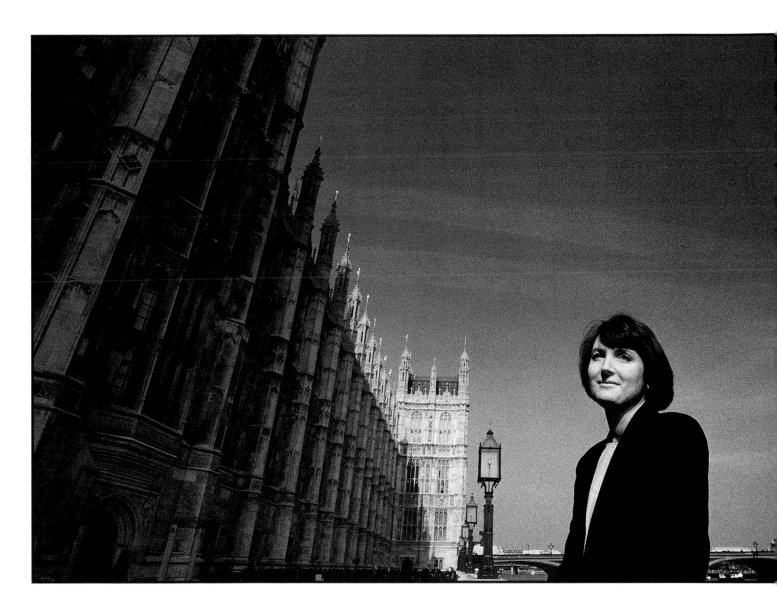

▶ First try

This portrait was
commissioned for a
book. The picture
was shot straight,
but I was aware that
exposure contrast
between the figure
and the Houses of
Parliament was
going to be too great
for a dramatic print.

▲ Flash for contrast control

I wanted the building to be clearly visible, to
emphasize Harriet Harman's role as a Member
of Parliament, so I used flash to alter the
contrast. My assistant stood on a chair and
directed the flash at her face, using an
extension cord, and I cut exposure on camera
by 1 stop to get a rich, dark, tonal background.

*28mm lens; HP5+; ¹/₂₅₀ sec at f/16. Printed on
Ilford MGW 1K for 15 secs; f/5.6. Building
shaded for 5 secs; sky burned in for 4 secs.*

Studio lighting

After years of experimentation with every weird and wonderful combination imaginable, I have settled on a few simple lighting set-ups. I tend to use a single light source, and with the use of reflectors, I try to reproduce natural daylight situations. Many of the great black-and-white studio photographers — Avedon and Penn, for example — have used only two or three (at the most) lighting set-ups.

I use both flash (Bowens, Balcar, Elinchron) and tungsten lights. I would recommend tungsten for beginners because you can read the lighting much in the same way as you read daylight. Flash, on the other hand, takes quite a bit of experimenting with before you feel in control.

The shot on the right was originally in color. I made an interneg to turn it into a black-and white shot to emphasize the round shapes. The lighting set-up below is one that I use if the composition is complex, as it is here with two sitting figures. Shadows would have been too messy. I flashed the print during development to hold an edge to the picture.

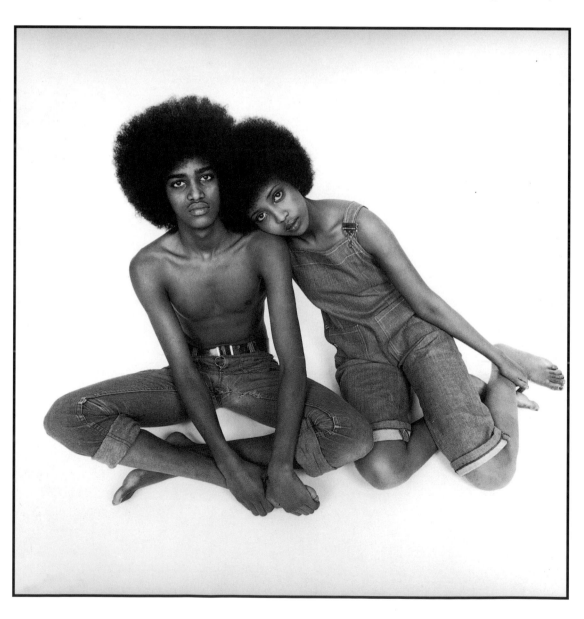

▶ **Dorrine**

I used a high overhead flash with umbrella. *105mm lens; Ektachrome 100; 1/125 sec at f/16; interneg made on HP5+. Printed on Ilford MGW 1K for 15 secs; f/8 at grade 2. All body highlights burned in for 10–20 secs at grade 1.*

◀ **Siblings**

A Bowens 2000 studio flash was bounced into a large silver umbrella. The light is behind the camera and 8' high. *Hasselbad 50mm lens; flash synched at f/11; HP5 rated at ISO 320. Printed on Ilford MGW 1K; 20 secs at f/5.6, grade 3. Print flashed in during development.*

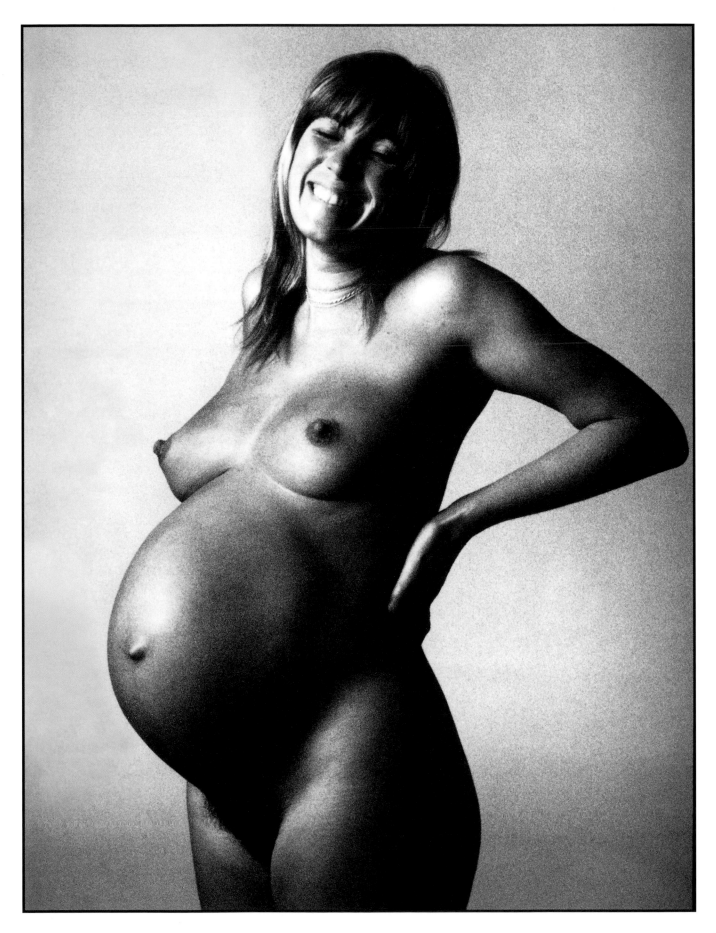

Lighting for portraits

Early on in my career, I must confess, I was more keen to demonstrate my lighting virtuosity than I was to produce a sympathetic portrait of the person I had lured into my studio.

The person being photographed should dominate the picture and dictate to the photographer what lighting to use. The lighting provides the mood by contributing to the tonal composition of the portrait.

However, the other contributing factors of tonal management, such as clothing and background, need to be considered before you set up the lights. The personality of the sitter is also critically important. Furthermore, the lighting needs to be sympathetic to the bone structure of the face.

So, spend as much time talking to your subject and observing them as possible. The appropriate light will become clear for you.

If possible, a black-and-white polaroid is very useful as a guide to your lighting.

My early portrait lighting was learned by trying to copy that of my heroes. It's a good place to start — your own style will soon develop.

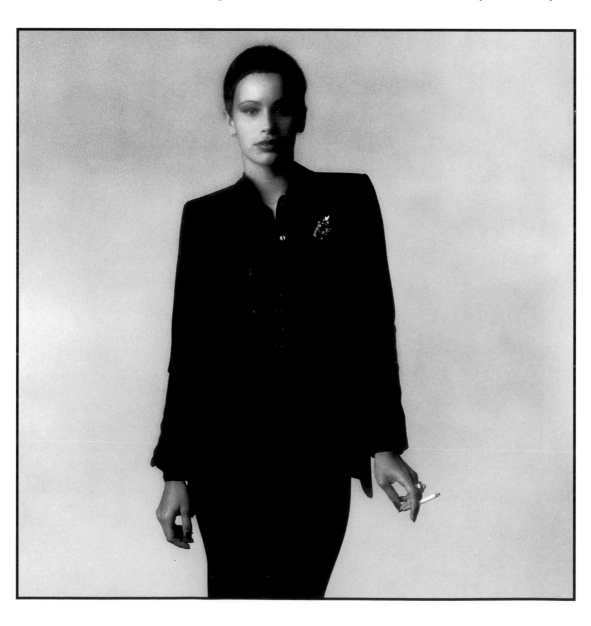

◄ **Rio**
An elegant stance is enhanced by simple tonal composition. I bounced a single flash into an umbrella. *Hasselblad 150mm zoom lens, with Softar filter; HP5; synched to flash at f/16. Printed on Ilford MGD 1K for 20 secs; f/5.6 at grade 3.*

► **Sir Martin Flett**
I bounced floodlight out of a large white umbrella and a desk was covered with a silver reflector. *80–200 zoom lens on 135mm; HP5; $^1/_{125}$ sec at f/5.6. Printed on Ilford MGD 1K for 16 secs at f/5.6 at grade 3½. Forehead burned in for 3 secs; eyes held back for 3 secs.*

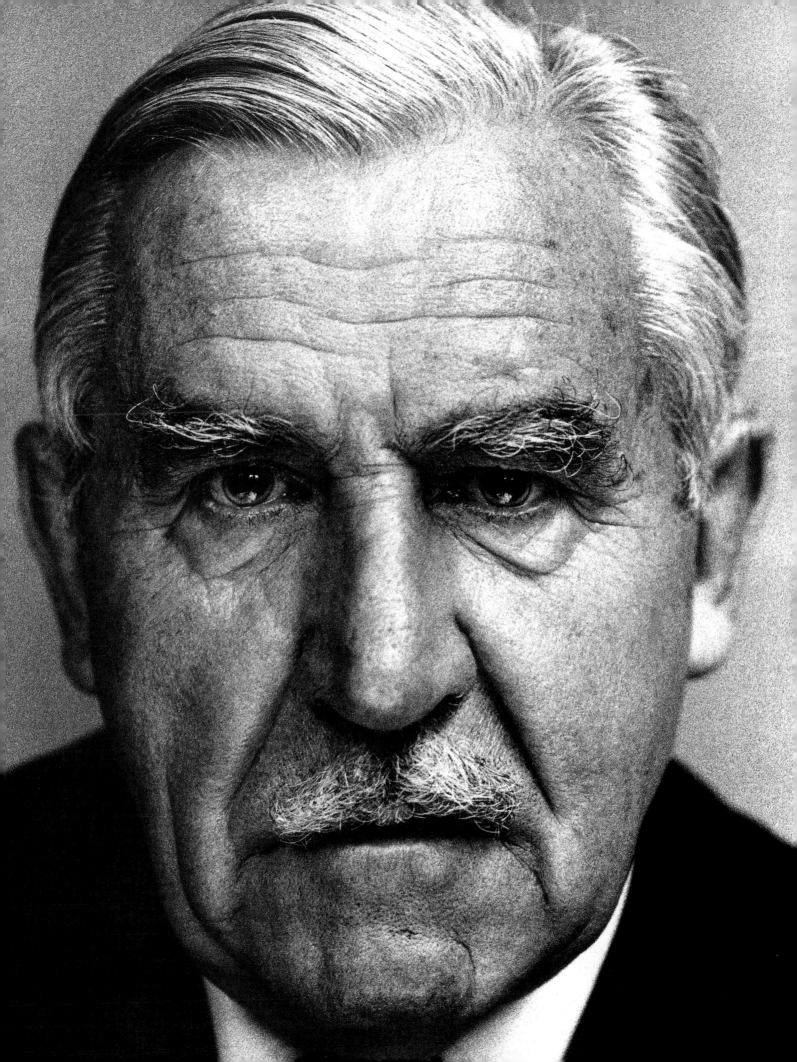

Studio light with reflectors

These portraits of the late Sir John Betjeman were for the cover of his *Banana Blush* album. I played with the light to try to create the atmosphere of the '30s and '40s movies, since the poems he was reading for the album came from that era.

I think it is worth suggesting at this point that when you set up a single light on a face, go through the exercise of taking a picture sidelit, three-quarter-lit, frontlit and lit from below, just to find out for yourself how a light can seemingly change the shape of a face; use reflectors where necessary, to balance the lighting and eliminate unwanted shadows.

I have done this in several books before, including *The Art of Black and White Photography,* and many readers will be aware of this single-light exercise. But for those who haven't given it a go themselves, it is a useful lesson in tonal management with light.

Which of the lighting alternatives you prefer is just a matter of taste, but the exercise demonstrates the usefulness of reflectors in studio (large pieces of white card or sheets will do). I like to keep my lighting very simple: one light source, and reflectors to alter the tonal balance.

▶ **Single sidelight with reflector**

For this shot I used a single Lowell mono light, or spot, from the side at about waist height. I filled the shadow this created by using a large white reflector board (a 6 x 4 feet sheet of polystyrene) opposite the light source.

Hasselblad 80mm lens; HP4; ¹/₁₂₅ sec at f/5.6. Printed on Ilford MGD 1M for 15 secs; f/5.6 at grade 2.

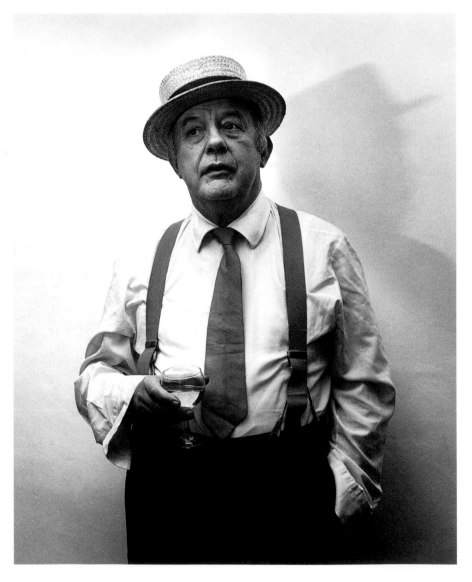

▶ **Sidelight alone to accentuate the shadow**

In this second shot, the main light is in the same position as before, except this time the reflector is not used. The strong shadow that this leaves does not work with all portraits, but in this instance I think it helps evoke the period of the '30s and '40s.

Hasselblad 80mm lens; HP4; ¹/₁₂₅ sec at f/5.6. Printed on Ilford MGD 1M for 15 secs; f/5.6 at grade 2.

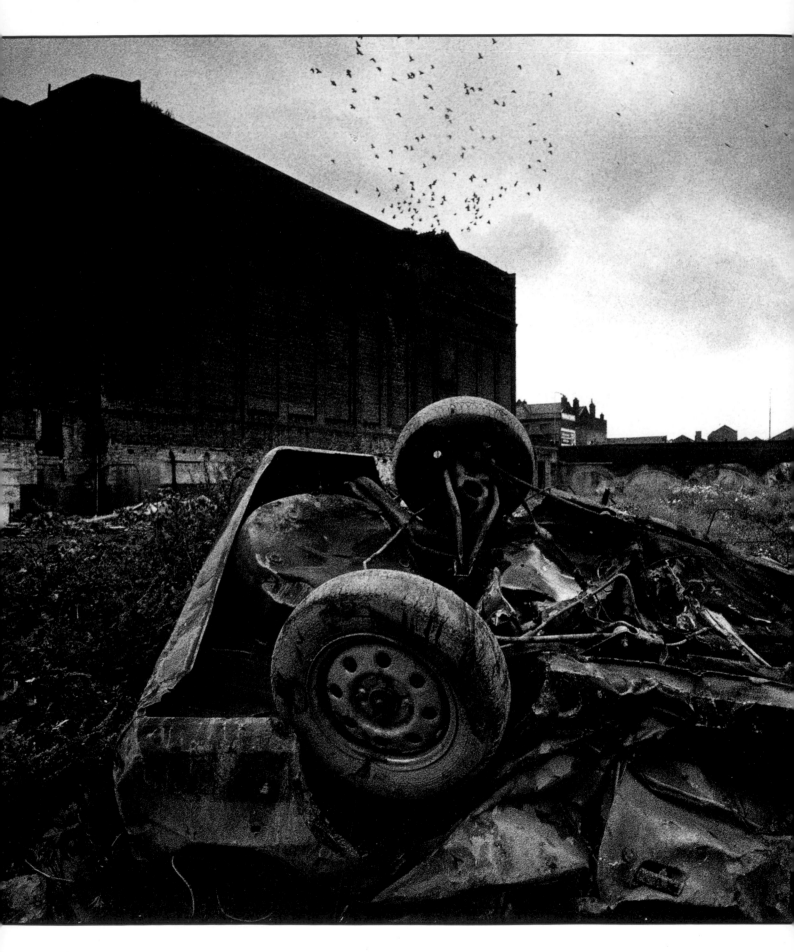

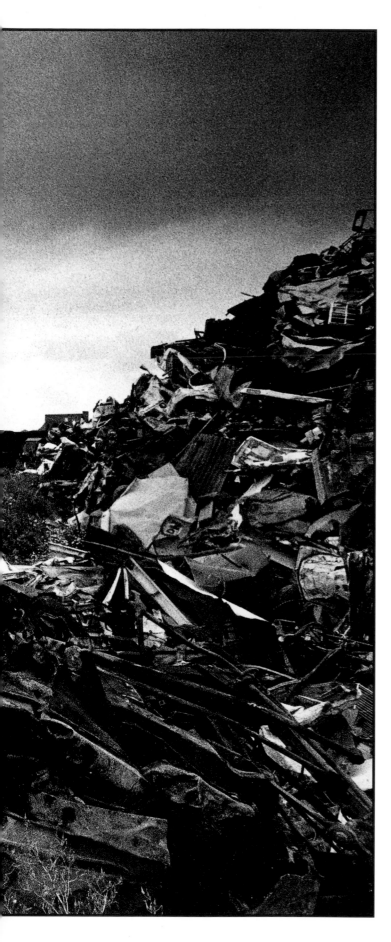

Printing

◄ Liverpool, England

Shot as part of a photo-story on inner-city decay, I used a graduated neutral density filter to darken the top third of the picture. The filter has added drama to the foreground junk. I could have burnt in the filtered area in the darkroom but preferred being able to visualize the final shot in the camera.

18mm lens; T-Max P3200 rated at ISO 1600; 1/350 sec at f/11–f/16. Printed on Ilford MGW 1K for 20 secs; f/5.6 at grade 3½. Car held back for 5 secs; bottom left corner burned in for 4 secs; white plastic in rubbish pile burned in for 30 secs.

Assessing negatives

I always try to produce a negative that has a good range of tonal information so that I have the option of printing it several ways. But as we all make mistakes, I sometimes end up with a negative that is less than ideal.

When this happens, it is important to keep an open mind as to what is possible in the darkroom. The reassessment may be more exciting than what was originally planned.

Try to separate your two different roles — as photographer and printer. Assess your negatives as a printer would who wasn't on the shoot. A specialist printer would assess my negatives differently and make very different prints.

When I print an old negative that I haven't worked on for some years, I often end up doing it differently from my original interpretation — having become more the printer than the photographer.

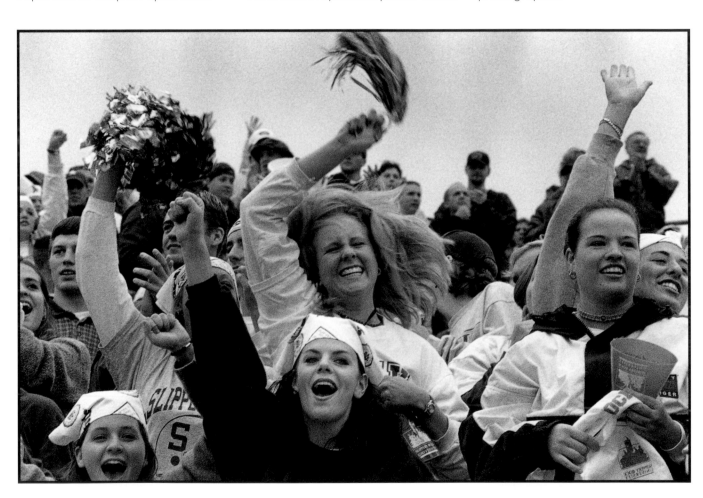

Perfect negative

Soft, overcast light has assisted in producing a negative that almost prints itself. There is a full range of tones, from black right through to white. As such, it could be printed onto a medium grade of paper without any need for manipulation.

80–200mm zoom lens at 200mm; Tri-X; ¹/₂₅₀ sec at f/8–f/11.
Straight printed on Ilford MGW 1K for 16 secs; f/5.6 at grade 2½.

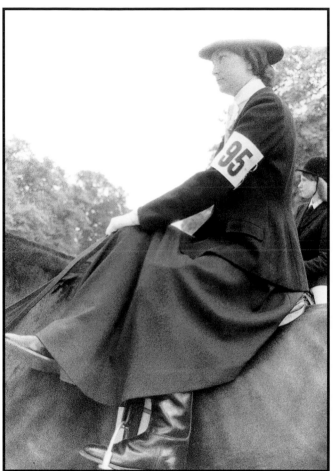

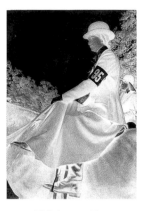

◄ ▲ Thick negative

This negative has been severely overexposed (by 2 to 3 stops). The highlights are clogged up, reducing the sharpness. With effort I could save this picture in the darkroom, but it would never make a great print.

35mm lens; HP4 rated at ISO 600; ¹/₁₂₅ sec at f/8. Straight printed on Ilford MGD 1M for 50 secs; f/4 at grade 2¹/₂.

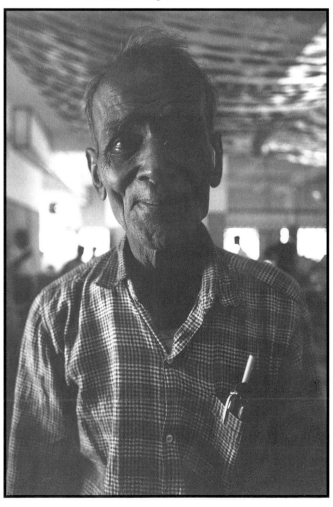

► ► Thin negative

This shot has been underexposed by 2 or more stops. The negative is still printable on the highest contrast paper available, but there is very little shadow detail, and the resulting print is very muddy.

28mm lens; HP4; ¹/₂₅₀ sec at f/2.8.
Straight printed on Ilford MGD 1M for 5 secs; f/5.6 at grade 5.

Basic printing

The first step in the printing process is to make a sheet of contacts from the negatives. I use transparent negative sleeves so that I can make contacts with the negatives in the sleeves — saving having to handle them unnecessarily.

I make my contacts on a soft grade of paper so that I can read the full tonal range of the negatives. The contact sheet is a useful guide for choosing which picture to print, but I make the final choice from the negatives themselves, using a light box that I keep in the darkroom.

The next step is usually a test strip. I only use test strips as an exposure starting point if I haven't been printing for a while. If I'm printing consistently I go straight to a test sheet — a piece of the paper I'm working on torn in half. I make several of these test-sheet exposures to assess the exposure and grade of paper. If it is a tricky negative, I make separate test prints for the highlights, shadows, and overall exposure. By taking the time to do this, you can be confident of getting pretty close on your first attempt, and you save paper in the end.

The first print is usually just that; even on my best days, I would expect to need a second. More likely, a third or fourth print is necessary to really fine-tune the image.

When I have completed the final print, I cut out the contact of the print and stick it in my darkroom diary, writing down all the printing details. This is a good teaching tool and also a great time saver next time I print the sheet.

It's only fair to say that even the best print makers have their bad days. We are not machines and producing good prints takes a lot of creative energy. Don't get too frustrated if some days you just can't print for toffee. Take an hour's break and start again.

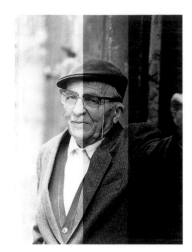

▲ **Test strip**

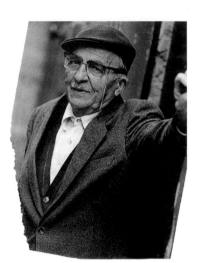

Test print

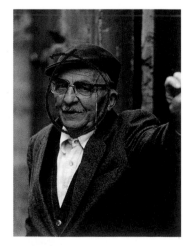

▲ **First print**

◄◄ **Contact strip**
The contact strip is
made on grade 1
paper to reproduce
the tonal information.

◄ **Test strip**
A three-stage test
strip has given me a
guide to exposure.

◄ **Test print**
I decided to add half
a grade more
contrast.

◄ **First print**
Slightly darker and
contrastier, but I
decided to shade the
man's face to "lift" it
from the background.

► **Final print**
Same exposure, but
shirt and hand
burned in.

All: *80–200mm zoom
lens at 200mm;
HP5+ rated at ISO
600; $^1/_{250}$ sec at f/4.
Printed on Forte
Warmtone FB for 22
secs; f/5.6 at grade
3$^1/_2$. Final print: face
shaded for 5 secs,
hand burned in for 5
secs, shirt burned in
for 7 secs (all at
grade 1$^1/_2$).*

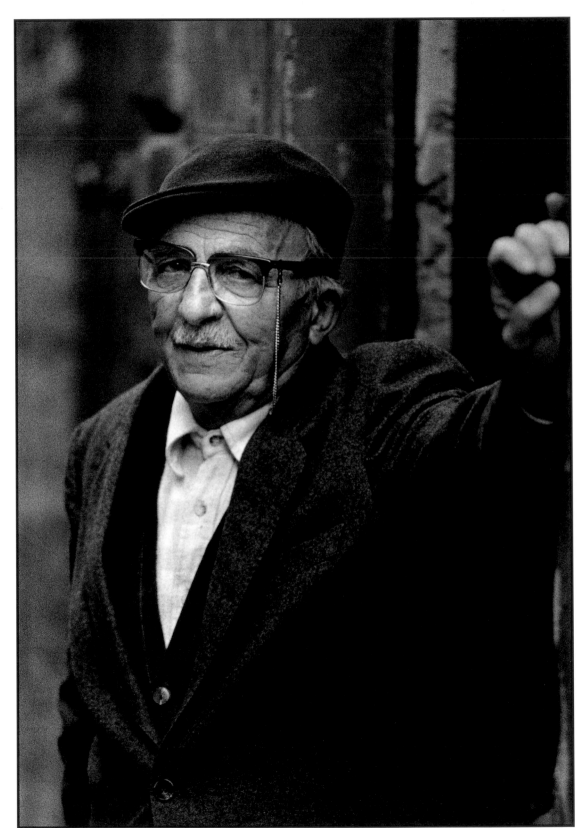

Paper contrasts

The first decision a printer makes when assessing a negative is to decide which grade paper is appropriate. Traditionally, papers came in five grades, or contrasts, grade 1 being a very soft contrast and grade 5 giving the hardest contrast. Graded paper is still made; however, variable-contrast, or multigrade, papers have virtually taken over for most printers; I now only use this type for printing.

Different filters are used in the enlarger to get the different grades. For me, there are three great advantages to this: it's less expensive, as you only require one box of paper, rather than five; you have more grades to choose from — half-grades are possible, and I even have a multigrade head on my enlarger that allows infinitely graded filtration; and you can change grades during a print, increasing or decreasing contrast in problem areas.

▶ **One picture at three contrasts**

I shot this portrait outdoors with the assistance of a glowing, late-afternoon light. I didn't want any distracting background: he has a great face; so I filled the frame with it. The resulting negative could produce a satisfactory print on any grade of paper, so it was ideal for illustrating the grading system.

▲ **Grade 5 — hard contrast**

▶ **Grade 3 — medium contrast**

◁ **Grade 1 — soft contrast**

All three prints taken from the same negative. 80–200mm zoom lens; HP5 Plus; $^1/_{1000}$ sec at f/4. Printed on Forte Warmtone FB for 17 secs; f/5.6 at grades 1, 3, and 5. Face straight printed, but background and clothing burned in for 9 secs.

Multigrade paper

Multigrade, or variable-contrast, paper is the greatest development in black-and-white photography in a very long time, as far as I am concerned. But it is the ability to use several grades of filter during the printing of a single picture that particularly interests me. It is a technique that I use on practically all of my prints, as you will have noticed from the captions in this book.

The most usual practice when printing on multigrade papers is to make the general exposure on one grade, say grade 3, and then to burn in the extreme highlights on a softer-grade filter, say grade 1.

However, I often do the reverse. I print the general exposure on a medium grade (2½–3½) and then burn in a mid-tone, or a soft area that I feel requires a boost, on a hard-grade filter (grade 4½ or 5). This is a great method for re-visualizing the picture after the event. It enables me to increase the print's drama in the darkroom in a way that I was unable to do with the camera. The landscape image used here is a simple example of just how effective the technique can be.

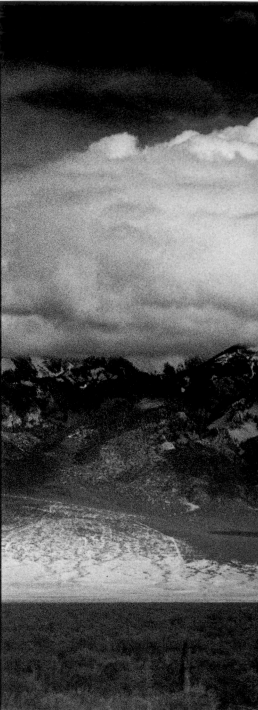

▼ **Straight print**

80–200mm zoom lens at 200mm, with orange filter; T-Max P3200 rated at ISO 1250; ¹/₂₅₀ sec at f/11–f/16. Printed on Ilford MGW 1K for 16 secs; f/5.6 at grade 2½.

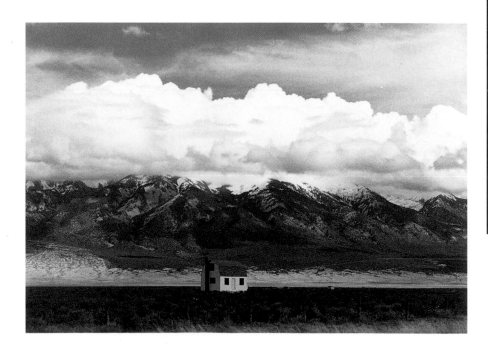

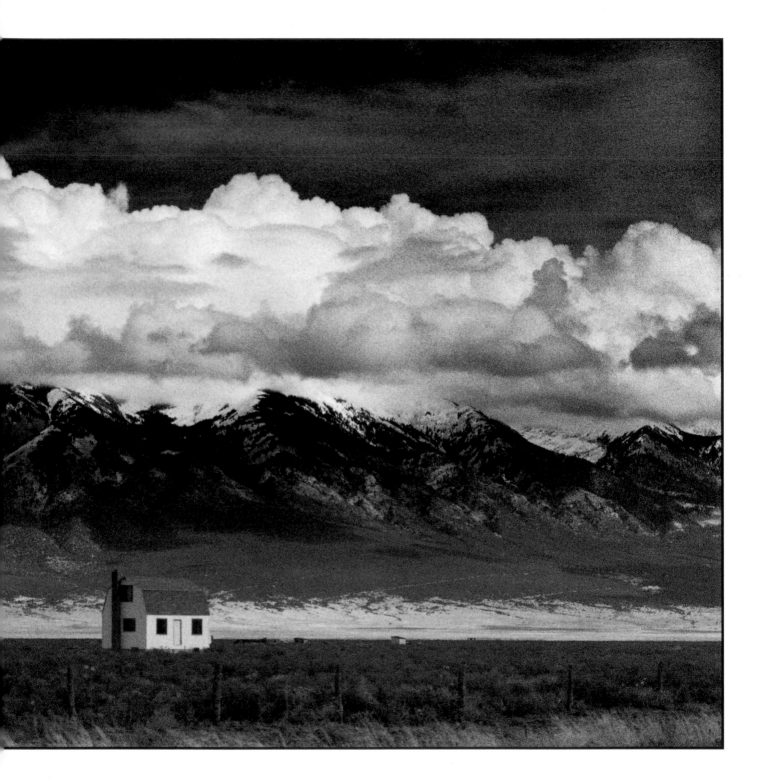

▲ **Two grades in a single print**

80–200mm zoom lens at 200mm, with orange filter; T-Max P3200 rated at ISO 1250; ¹/₂₅₀ sec at f/11–f/16. Printed on Ilford MGW 1K for 17 secs; f/5.6 at grade 2½. Grass burned in at grade 2½; sky and mountains burned in for 6 secs at grade 5; sky graduating to top of frame an extra 15 secs at grade 5.

Burning in

Print making is a subtle craft. The difference between an average and an excellent print can be just a matter of a second or so of burning or dodging in. These two techniques, where selected areas of a print are given more or less exposure than the rest, are essential to nearly all my prints.

This portrait of John Pilger was shot in very gloomy conditions.

But the light was making bright highlights on his forehead and nose, and creating deep shadows in the eyes, even with a reflector.

I shaded back the eyes a little with a small dodger, and burned in the bridge of the nose and top of the forehead. Multigrade paper makes this task so much easier than graded papers. I was able to produce a fairly contrasty print, yet could burn in the highlights using a grade 1½ filter.

I burned in the forehead using my hands as a mask. For the nose I cut out a small hole the shape of the highlight in a white card and burned in through the hole. I could see exactly what I was doing because the negative was perfectly projected on the white card.

▶ **John Pilger**

This portrait of journalist John Pilger was shot for the cover of his book, *Secret Lives*. In this straight print the eyes are almost black. The bridge of the nose and the forehead are too bright. I have marked the areas that need attention.

80–200mm zoom lens at 180mm; Fuji Neopan 600 rated at ISO 1600; ¹/₂₅₀ sec at f/5.6. Straight printed on Ilford MGW 1K for 12 secs; f/5.6 at grade 3.

▶ **Final print**

I needed three attempts to produce this print. I shaded the eyes during the basic exposure and then burned in the nose and the forehead in two separate exposures.

80–200mm zoom lens at 180mm; Fuji Neopan 1600 rated at ISO 1600; ¹/₂₅₀ sec at f/5.6. Printed on Ilford MGW 1K for 21 secs; f/5.6 at grade 3. Eyes dodged for 5 secs; bridge of nose burned in for 12 secs; forehead burned in for 5 secs; forehead top right burned in for 6 secs; background and shirt burned in for 12 secs (all at grade 1½).

Flashing in

Flashing in does not require a flashgun, but rather involves a quick flash of tungsten light to the printing paper, either before exposing the print in the enlarger or during print development. I think "pre-flash" and "dev-flash" are more appropriate descriptions.

Flashing is used in order to fog the print's highlights. It comes in handy when you find the paper can't produce detail in the extreme highlight areas of a particular negative; the flash of light fogs in the highlights without damaging the shadows.

Pre-flashing is the more consistent of the two methods. You can do this in the enlarger — I don't take the negative out, I just hold a piece of tissue paper over the lens and flash for a fraction of a second. The exact exposure and aperture depend on the paper and the negative you are printing.

For the dev-flash technique, I have a tungsten light on a dimmer switch about 3 feet (1 meter) above the developer dish. I slip the paper into the developer very carefully so as not to cause a current or bubbles, since these throw a shadow onto the print when the light is flashed on. For a fiber-based paper I flash at between 45 and 60 secs into development (25–35 secs on resin-coated paper). The light is dimmed to around 10 watts and the exposure is approximately $^1/_4$–$^1/_2$ sec. Don't agitate the print. I snatch the print from the developer as soon as I see a tone appear in a white highlight or on the print border.

Flashing is a frustrating technique, but it is one that I use often because it allows me to work on a higher grade of paper than would otherwise be possible.

◄ Straight print

On grade 3 paper, the window is burned out.
35mm lens; Tri-X rated at ISO 320; $^1/_{250}$ sec at f/11. Printed on Ilford MGW 1K for 13 secs; f/5.6 at grade 3. Shadow area held back for 4 secs.

▲ Flashed during development

The dev-flash technique was used to obtain some detail in the window shades, without having to use a softer grade of paper.

35mm lens; Tri-X rated at ISO 320; ¹/₂₅₀ sec at f/11. Printed on Ilford MGW 1K for 13 secs; f/5.6 at grade 3¹/₂. Shadow area held back for 4 secs; flash during development.

Toning

There are two major reasons for toning a print. The first is the overall color tone it adds to the image. The second, is the archival longevity it gives to a print. When selling prints for large sums of money in a gallery, the stability of the image is obviously very important. The three toners used mostly for this are sepia, gold, and selenium.

Sepia produces a brownish tone, and, if this is not appropriate, a selenium toner is used, as it produces a very subtle purplish-to-brownish tone (dependent on the paper used), that only alters the mood of the print slightly. Gold toning usually creates a bluish tint.

Toning is not nearly as haphazard or smelly as it used to be. The range of one-bath toners is terrific. The variety and control of color you can produce is almost limitless. I personally prefer rather subtle color shifts, but stronger hues are possible.

You will need to make your own experiments because there are a variety of toning kits on the market that all vary considerably. Of paramount importance is the fact that toners produce different colors on different papers. Generally speaking, I find that fiber-based papers respond best to toning, although some toners work well with resin-coated papers.

Most toners have a bleach-back quality — they strip the tone away from the highlights, giving a more

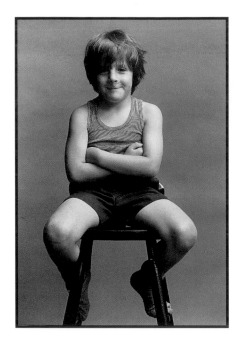

▲ **Gold-toned**

85mm lens; HP5; ¹/₁₂₅ sec at f/5.6. Printed on Ilford MGW IK for 16 secs at grade 3; f/5.6. Shadow on face held back for 2 secs; left shoulder and thigh burned in for 3 secs at grade 1½; gold-toned for 12 mins.

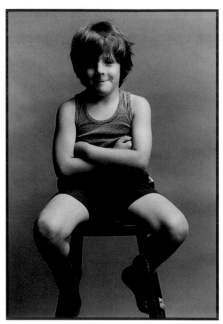

▲ **Selenium-toned**

85mm lens; HP5; ¹/₁₂₅ sec at f/5.6. Printed on Ilford MGW IK for 16 secs at grade 3; f/5.6. Shadow on face held back for 2 secs; left shoulder and thigh burned in for 3 secs at grade 1½; selenium-toned for 8 mins.

contrasty image. I find this quality really dramatic on some subjects.

The most valuable tips I have learned by cruel experience are:

1. Make sure that you wash the print very well. If you leave fix in the print, it will bleach back too much.

2. Most toners reduce the print density by ⅓–1 stop, so make the prints darker than is good to the eye. Most toners increase the contrast by ½–1 grade, so make prints softer than normal.

3. Produce plenty of prints to work on before toning so that you can experiment with the color.

4. Keep a notebook and records of every step for each print.

5. Make sure that you have an exhaust fan in the darkroom.

6. Fastidious cleanliness is essential — wash down everything that's been in toner contact, otherwise staining is a certainty.

▶ **Sepia-toned**

35mm lens; HP5; ¹/₆₀ sec at f/5.6. Printed on Ilford MGW IK for 15 secs at grade 3; f/5.6. Face held back for 4 secs; slippers, back and foot burned in for 4 secs at grade 1½; top of frame burned in for 25 secs at grade 1½; sepia-toned. Bleached for 1 min; toned for 2 mins in Film+ sepia toner.

Toning with a kit

I made all these toned prints using the Palette Toner Kit, one of several one-bath toner kits on the market. I like them because they don't require a bleach bath prior to toning and you can produce an enormous range of tones. With practice I really have begun to feel in control, which is quite a recent experience for me when it comes to toning.

You can also produce split-tone effects — that is to say, two or more colors on the same print — with relative ease using this kit. By juggling the toning times of different colors you can control the effect — but do remember to number each print on the back, and document what you have done in a darkroom diary, otherwise you will never be able to repeat the effect later or learn from your experiments.

These toners work very well with resin-coated papers, which is a big bonus (all these prints are on resin-coated paper). I start by re-washing the original prints because wet prints respond more quickly and more evenly than dry ones. Each color toner in the kit has an intensifier or activator that you add to the toner to increase the saturation of the colors. I find that the blue toner doesn't reduce the density of the print. All the other colors lighten the original image considerably, however, so one needs to print the originals about 80 percent darker than normal.

▲ **Original print, untoned**

▲ **Blue toned for 2 mins**

▲ **Blue toned; washed in hot water before fixing**

▲ **Blue toned with intensifier, giving a stronger blue**

▲ **Titanium-yellow toned for 45 secs for split-toned look**

▲ **Titanium-yellow toned with activator**

▲ **Red toned for 5 mins – toner has greatly reduced density**

▲ **Split toned: red toned and then blue toned**

▲ **Green is made by toning in blue then yellow, before fixing.**

▲ **Red tone for 1 min; short toning time gives subtler color**

Bleaching

Overall bleaching, or bleach back of a print, is usually just the first stage in the traditional split-toning process.

However, an overall bleach can be very effective as a single process. I often use a very subtle bleach back to add sparkle to a print, but I also like the effect of quite severe bleach back. As with toning or lith development, bleaching produces different tones and contrasts on different papers.

Always start with a well washed print. I find it needs to be 30 to 100 percent darker than pleases the eye. I use Famer's solution (potassium ferricyanide and sodium thio-sulphate fixer), which I buy in powder form. Generally, it is best to start with a fairly weak solution so that the print does not bleach too quickly. Keep all your best prints until last and never put them straight into the bleach without experimenting first.

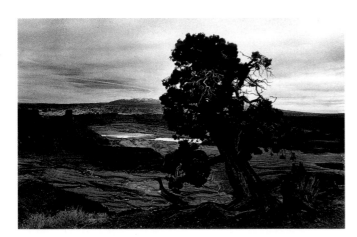

◄ **Before bleaching**

Unbleached prints should be about 40 percent darker than normal.

Printed on Forte Warmtone FB for 28 secs; f/5.6 at grade 4. Sky burned in for 8 secs at grade 1½.

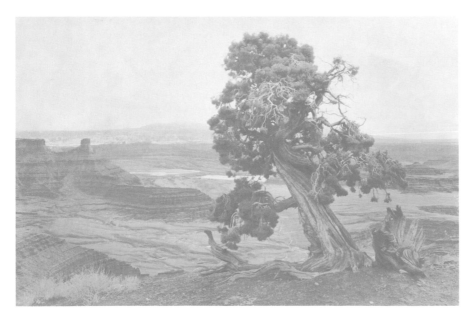

◄ **Too light**

My bleach was too strong and the print was not sufficiently dark, so by the time I pulled it from the bleach it was too late. The bleaching continued in the wash. You need to pull the print out before it is at the required density.

Printed on Forte Warmtone FB for 20 secs; f/5.6 at grade 4. Sky burned in for 5 secs at grade 1½; bleached for 30 secs.

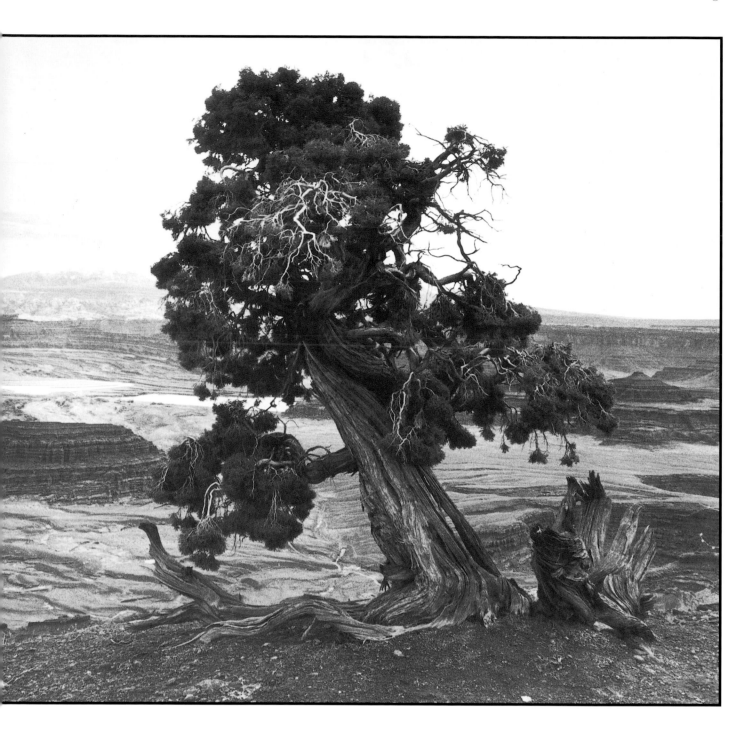

▲ Final effect

Using a denser print (as top left), I bleached the print back in a weak solution. It took five minutes altogether to bleach, but I did it in four stages, washing it for 20 secs at intervals to make sure I didn't overcook it again. This picture was shot on a very misty overcast day — totally unsuitable for landscape photography. I used Ilford SFX 200 infrared film with a red filter, which did a great job of cutting through the mist to give me detail at infinity and increase contrast.

All three photographs: 28mm lens; Ilford SFX 200 infrared; $^1/_{250}$ sec at f/8. This print made on Forte Warmtone FB for 29 secs; f/5.6 at grade 4. Sky burned in for 8 secs at grade 1½, tree trunk held back for 6 secs; bleaching as described above.

Sabattier effect

The Sabattier effect occurs when you re-expose a print to light during the development and then keep developing. The print then begins to metamorphose back into a negative.

Sabattier uses exactly the same technique as flashing in (see pp110–111), except a slightly longer (or brighter) exposure is used and the print is kept in the developer for longer.

It is a simple technique but has considerable visual impact. You need lots of experimentation, because it is a hit-and-miss affair, and difficult to repeat.

▼ **Flashed during development**

I flashed in this print for about 1 sec after about 45 secs into development, with a 20W bulb above the dish. The print was then allowed to develop out for a further 2 mins. This was the second attempt. The first print was streaky. This a rather a haphazard technique, so don't be put off by a few failures.

35–105mm zoom lens at 90mm; T-Max 400 rated at ISO 320; $^1/_{250}$ sec at f/8–f/11. Printed on Ilford MGW 1K for 20 secs; f/5.6 at grade 3$^1/_2$. Flashed for 1 sec during development; developed out until Sabattier effect took over.

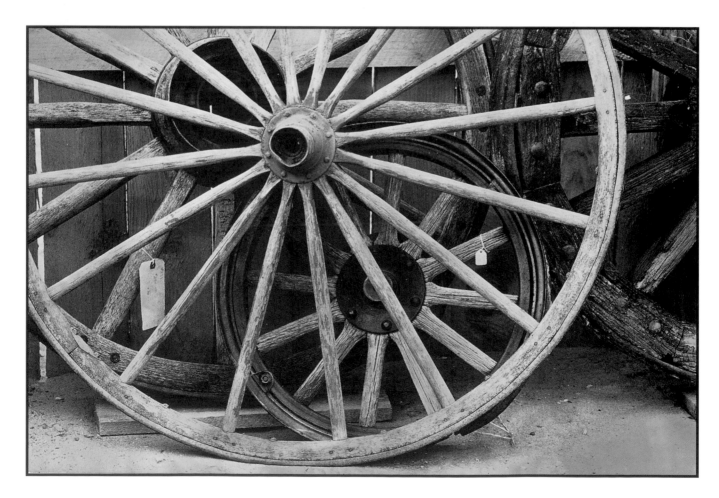

Soft filter

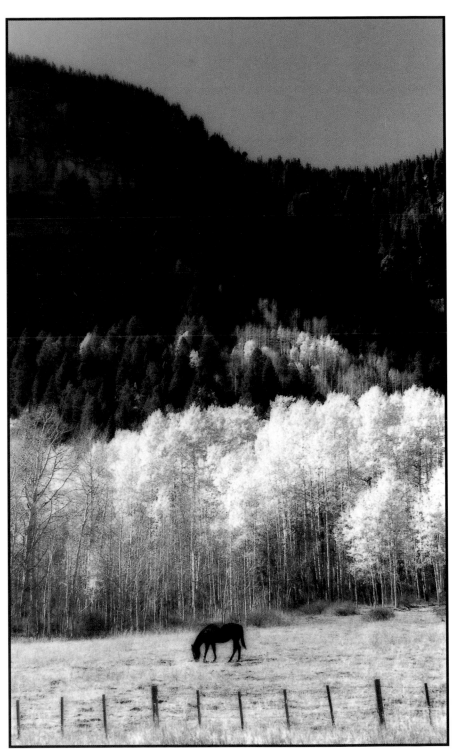

A soft-focus filter held over the lens during exposure will soften off the edges of the tonal composition. This is a useful technique if you are trying to perform cosmetic surgery on a face — to help hide wrinkles and skin blemishes. It can also be used for romanticizing a scene such as a landscape, as I have done here.

I usually leave the filter in place for only part of the exposure (for a third or half of the time) because I want a subtle effect.

To demonstrate the effect I have gone a bit over the top here and left the filter on during the whole exposure. Printers use all different filters. Some prefer silk stocking, some use anti-halation-ring glass, some use camera filters. I use a Hasselblad No1 Softar filter.

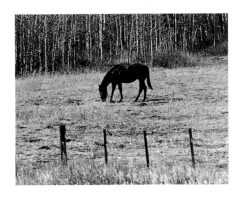

▲ **Straight print**

Printed without filter, all the tones in the picture are sharply defined.

35–105mm zoom lens at 105mm with red filter; Ilford SFX 200 infrared; ¹⁄₂₅₀ sec at f/8. Printed on Ilford MGW 1K for 12 secs; f/5.6 at grade 2½.

▲ **Soft-focus effect**

Printed with a soft-focus filter over the lens for the entire exposure. By diffusing for just a portion of the exposure, you can produce more subtle effects. I've deliberately exaggerated the technique for the purposes of this book, to ensure that it is clearly visible.

35–105mm zoom lens at 105mm with a red filter; Ilford SFX 200 infrared; ¹⁄₂₅₀ sec at f/8. Printed on Ilford MGW 1K for 12 secs; f/5.6 at grade 3. Areas held back for 4 secs, right-hand corner burned in for 3 secs. Hasselblad No1 Softar filter over lens.

Neg from hell

The "neg from hell" is the print-maker's description of a negative that is very, very difficult to print. Photojournalists are faced with more of this type of negative than most, simply because of the extreme conditions in which many of their photographs are taken.

"Negs from hell" also result from accidents, as has the example I've used here. The magazine on my Hasselblad was leaking light and fogging the film. I wasn't aware of the problem until I'd processed the film. My first response was to trash the film because it would be a nightmare to print. On second consideration I decided I liked the picture and told myself not to be a wimp — very few negatives are unprintable, but some take a long time and a lot of patience.

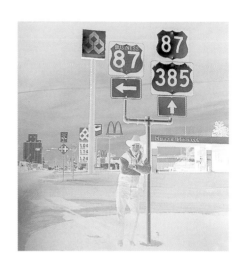

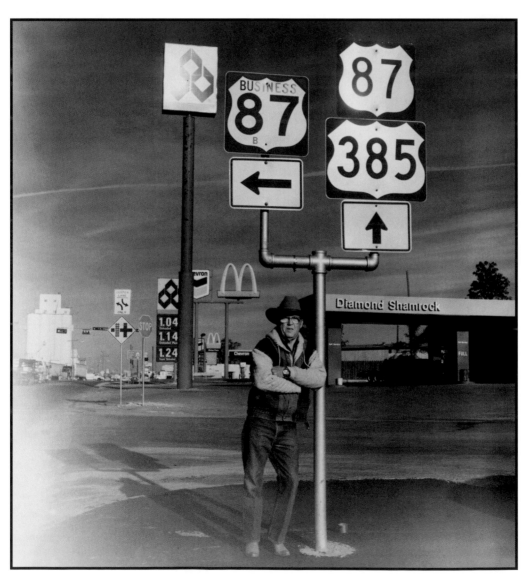

▲ **The negative**

◄ **A straight print**

► **The final result**

I cropped the picture vertically, to cut out the worst of the fogging, and got rid of much of the rest by printing dark and with a contrasty filter. I burned in the edges of the print. This is print No.8!

80mm lens with red filter; Delta 400 rated at ISO 320; $^1/_{250}$ sec at f/8. Printed on Forte Warmtone FB for 25 secs; f/4 at grade 4½. Face held back for 5 secs. Areas burned in at grade 2: left side for 45 secs; left bottom corner for 40 secs; top corners for 8 secs; below waist for 20 secs; right corner for 15 secs.

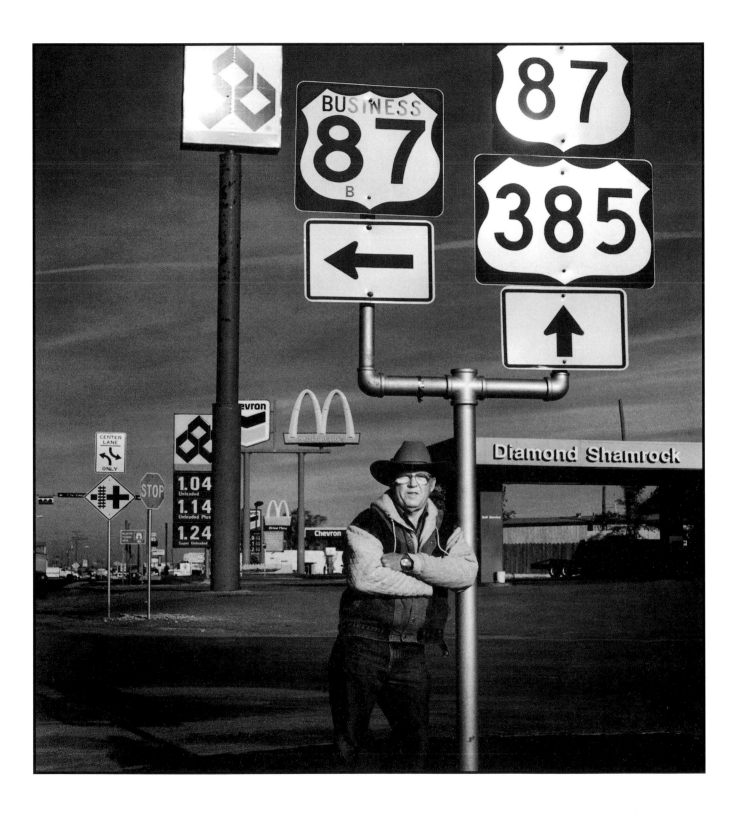

Retouching

I use localized bleaching to reduce small areas of a print that are hard to dodge, and spot pens to darken small areas on a dry print and to remove dust spots.

Localized bleaching requires patience and is more successful on fiber-based papers. Ensure your print is well washed to avoid staining, lay it on a sheet of Perspex, and wipe off excess water with a windshield wiper. I practice on rough prints. I use a weak bleach solution and apply it with cotton swabs or a fine sable brush. I bleach back the dark area bit by bit, washing off after each application. Bleach keeps working in the wash for a minute so don't overdo the last application.

Spot pens are very effective: you can wipe off any mistake. Remember: slowly does it! Cover the area with tiny spots, building up the tone until it matches the surrounding area. Pens come in packs of ten, ranging from almost white through to black.

▲ **Black eyes – too small to shade**

▲ **First try – bleach was too strong**

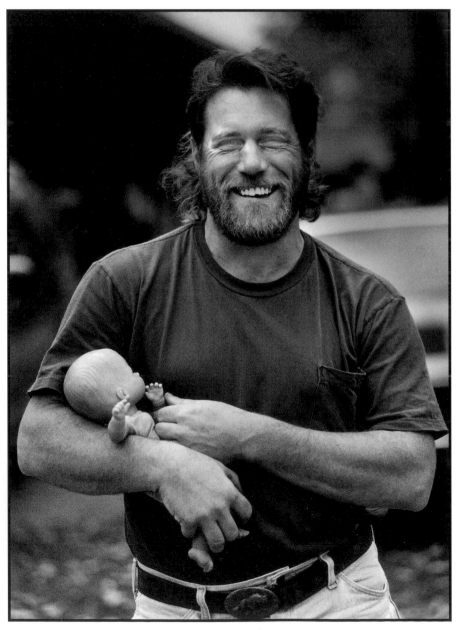

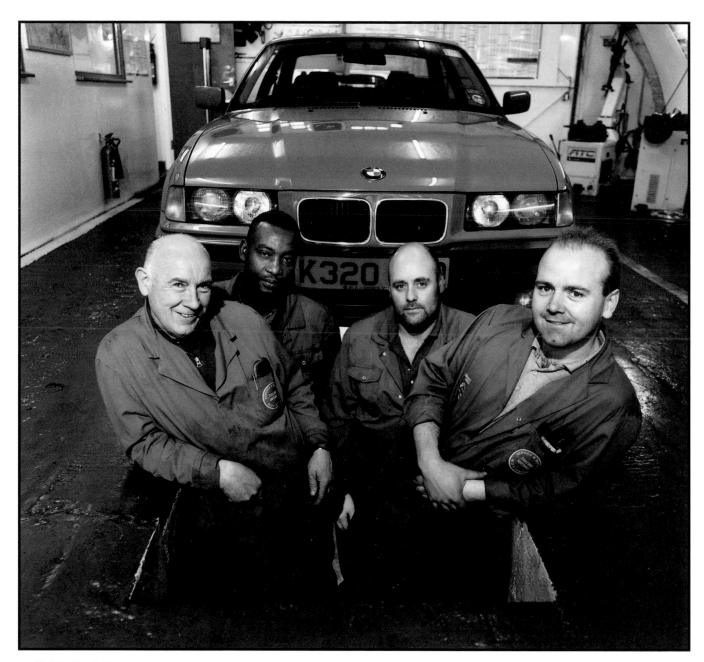

◁ Finished print

With weaker solution I gradually bleached the eyes.

80–200mm lens; Tri-X film rated at ISO 600; ¹/₅₀₀ sec at f/4. Printed on Ilford MGW 1K for 18 secs; f/5.6 at grade 3. Background burned in for 20 secs; baby burned in for 5 secs; eyes bleached.

▲ ◁ Spotting out a distracting license plate

It was not until I dried the prints off that the license plate on the car really started to bug me (see original print, left). I attempted to reprint and burn it in, but I had difficulty isolating the area. I spotted down the tone with a No. 7 spot pen. It was a long process, taking about an hour, but I prefer the picture without the bright central distraction.

Hasselblad 50mm lens; HP5+ rated at ISO 320; ¹/₁₂₅ sec at f/8. Printed on Ilford MGW 1K for 22 secs; f/4–f/5.6 at grade 3. Background around car burned in for 5 secs, foreground burned in for 4 secs.

Recropping

The baseboard of the enlarger gives the photographer a second chance to compose the picture. Although the aim is to compose in the camera, I don't agree with purists who dogmatically refuse to reframe in the darkroom. As photographers we can get locked into the original composition we made in the viewfinder, but it can be very rewarding to look at images afresh. Cut yourself off emotionally from having been there and look at your work again as a cold-eyed graphic designer.

This powerful re-composition of my picture was made by the art director of *Stern* magazine. He re-cropped it as a double-page spread in a story about children and violence. The re-cropped picture was then published by *Life* and *Paris Match*. The vision of the art director gave the shot a new life.

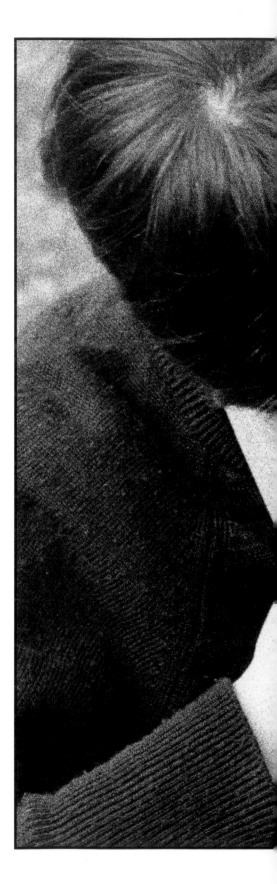

▶ **Recomposed**
The new crop has more tension. The little boy is crushed to the edge of frame with no escape.

105mm lens; HP5 rated at ISO 600; ¹/₅₀₀ sec at f/5.6. Printed on Ilford MGFB 1K for 14 secs; f/5.6 at grade 3½. Hands burned in for 5 secs, gun held back for 3 secs.

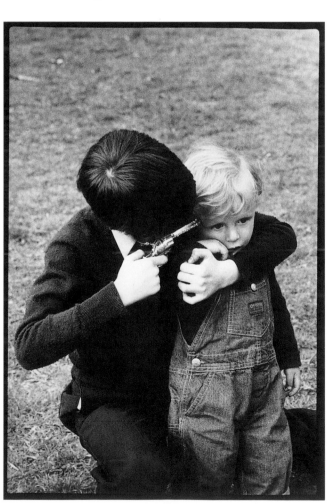

◀ **Original composition**
This is a reflex shot and the content is strong enough to make a good reportage image.

105mm lens; HP5 rated at ISO 600; ¹/₅₀₀ sec at f/5.6. Straight printed on Ilford MGFB 1K for 12 secs; f/5.6 at grade 3½.

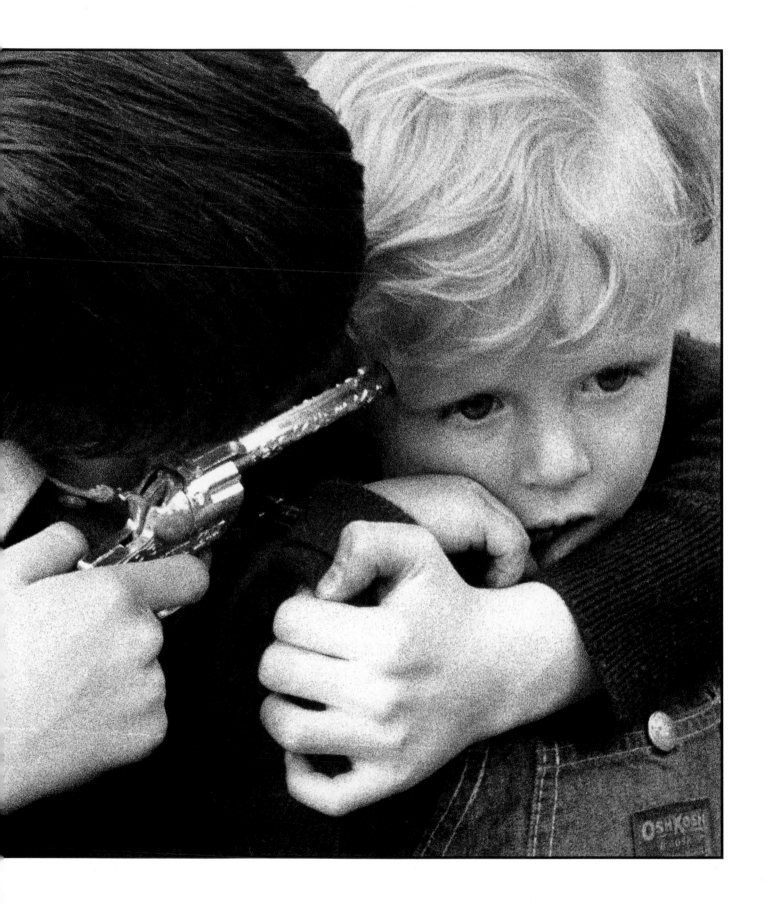

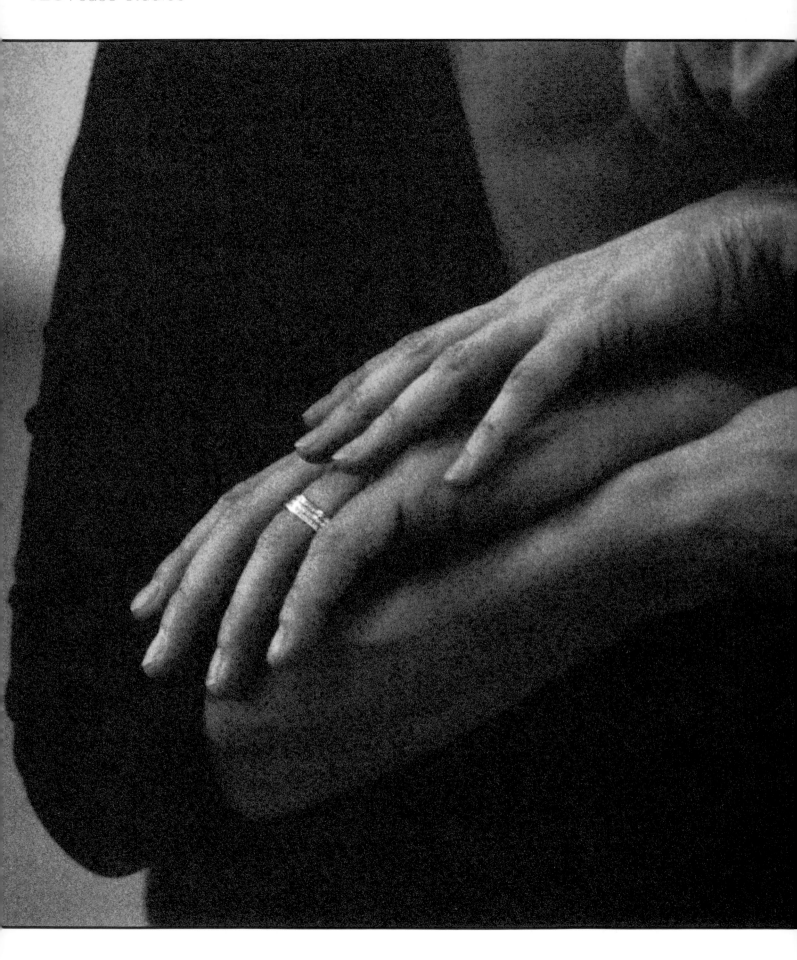

Case studies

◄ **Hands**

I was attracted by the sculptural look of this situation. The soft studio daylight provided a subtle tonal form, but much of the atmosphere was created in the darkroom. I decided to produce a dark and moody print by burning in the face to keep the emphasis on the hands and burning in the background for the same reason. The information was all in the negative, but the interpretation was definitely in the printing

80–200mm zoom lens at 200mm; HP5+ rated at ISO 1250; 1/125 sec at f/5.6. Printed on Kentmere Art Classic for 28 secs; f/5.6. Top hands shaded for 6 secs, face burned in for 12 secs, background burned in for 10 secs, bottom hands burned in for 8 secs.

Case study 1

Landscapes are an area of great disappointment in photography. The reason is that the eye flits around a scene, picking up various details. The brain interprets this as a beautiful picture, whereas the camera lens can only record what is in front of it.

I look for one powerful feature, around which I build the picture. Dramatic light, lensing, filtration, and choice of film are my building blocks. I zoomed in and chose a grainy film (T-Max 3200) and lith development as the finishing touch on this landscape (see pp 129 and 130–31) to capture the look of an old etching. The technique of developing bromide and chloro-bromide papers in lith developer is often called cross development.

(Lith developer is meant to be used exclusively with lith paper.) It produces tonal color shifts and increases the grain effect.

Lith developer reacts very differently on different papers, resulting in notably different tonal effects. The color is also affected by the length of development — the more exhausted the developer, the stronger the color.

You need to start off with about double the normal exposure. The print has a rather milky appearance in the developer, but this clears in the fix to give a high-contrast print.

Lith development takes patience and experimentation, but that very unpredictability and those surprises (not all pleasant) are what I enjoy.

The first view

The scene had no form or focal point. *80–200mm zoom lens at 120mm; T-Max 100 rated at ISO 80; $^1/_{250}$ sec at f/11. Printed on Ilford MGD 1K for 11 secs; f/5.6 at grade 3.*

Improving the composition

I walked around and found the focal tree and the elements for a strong tonal composition. *80–200mm zoom lens at 80mm; T-Max 100 rated at ISO 80; $^1/_{250}$ sec at f/11; red filter. Printed on Ilford MGD 1K for 13 secs; f/5.6 at grade 3. Sky burned in for 3 secs.*

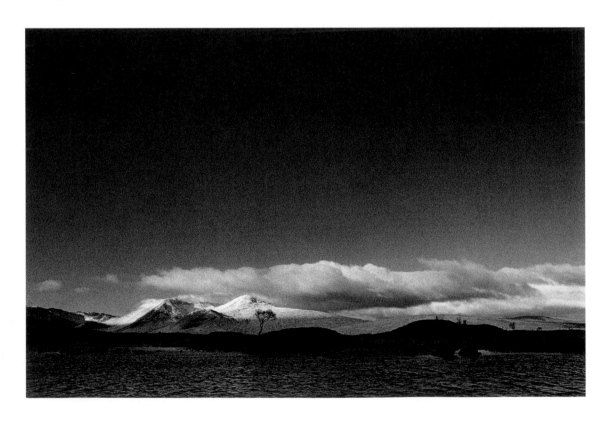

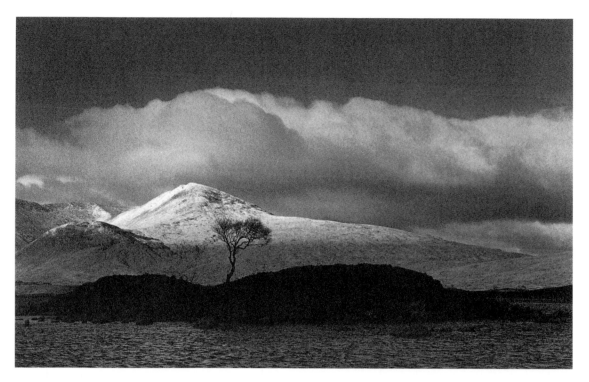

◄ The final compositions

Printed on Ilford MGW 1K for 27 secs; f/5.6 at grade 3¹/₂. Sky burned in 12 secs, grade 4¹/₂, sea held back 9 secs, peak burned in 8 secs.

▼ Printed on Kentmere Art Classic for 40 secs at f/5.6. Lith developed for 6 mins. Sky burned in for 10 secs; sea held back for 11 secs, peak burned in for 12 secs.

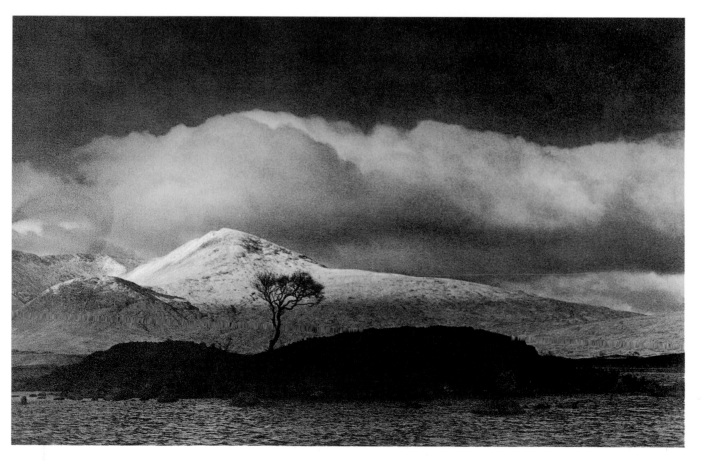

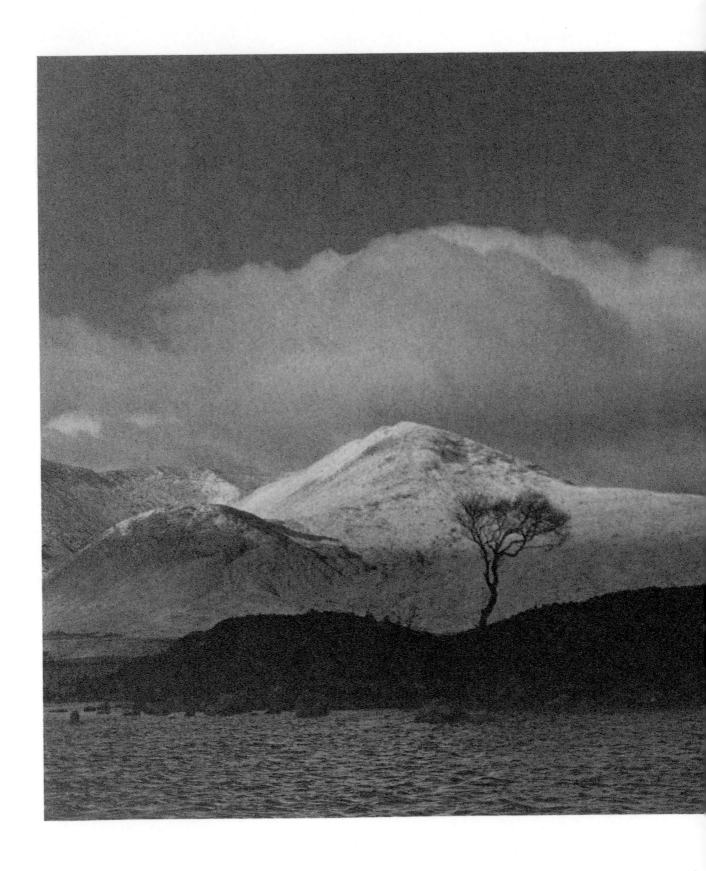

◀ **The final print**

I made this print on Forte Warmtone FB. I like the tone and the gritty effect the lith has given to the grain structure. I did produce a less chocolatey brown with a 4-mins development time, but the effect was rather sepia. Do be careful to wash the print thoroughly. I washed this print for 1 hour in my archival washer with the water temperature at 70°F. The most important factor in the archival longevity of a print is the water temperature of the wash. It is almost impossible to wash fix out of fiber-based prints in cold water of 60°F or less.

80–200mm zoom lens at 200mm with red filter; T-Max P3200 rated at ISO 1600; $^{1}/_{500}$ sec at f/5.6–8. Printed on Forte Warmtone FB paper for 32 secs; f/5.6 at grade 3½. Developed for 5½ mins in lith developer. Sky burned in for 14 secs, sea held back for 11 secs, mountain peak burned in for 10 secs.

Case study 2

I took these pictures during a six-month assignment with the Royal Ballet. I became increasingly fascinated and concerned by the amount of physical wear and tear ballet dancers endured for the sake of their very tough, demanding art form.

The moment I saw the physical therapist's hands massaging the foot I knew the situation had real possibilities, with the contrast between the powerful sun-tanned hands of the therapist and the pale, vulnerable-looking foot of the ballerina.

The light from the skylight was low in volume but had a glow to it. I immediately simplified the composition as soon as he cupped his hands around the foot. I felt that I had a good picture.

I'm sure that many compositions are influenced by imagery from our past childhood memories. In this case, I think I had a biblical flashback — of Christ washing the disciples' feet. This picture has become one of my most popular images — some have found it spiritual, others erotic.

For me, it is all about tonal composition and the protective shape of the cupped hands. The negative quality provided by the skylight has enabled me to almost give the print the appearance of a charcoal drawing.

The negative is difficult to print. It is thinner than ideal and the highlights down the ankle and foot

First attempt

In my search for a solution, I shot from every angle. The subject matter was strong, but I had not got to grips with it.

50mm lens; HP5+ rated at ISO 1250; ¹/90 sec at f/4. Straight printed on Ilford MGD 25M for 12 secs; f/5.6 at grade 2¹/2.

were very bright, requiring plenty of burning in. The toes required shading, and I burned in all the background so that it didn't detract from the main part of the picture.

In a more controllable situation I would have used HP5+ rated at ISO 320 and used a tripod. Not having to push the film would have meant less development and therefore a less contrasty negative. A reflector would also have helped. Every negative that is difficult to print has lessons to teach us.

The bottom line for this picture is the visualization of composition and light. The composition fulfills my most important rule: less is more. You need very few elements to make a good photograph, so keep it simple.

The two final prints shown pp134–35 are both on Kentmere Art Classic. One has an almost etched feel. The other is a cross-developed print. Which one you prefer is simply a question of personal taste. I like both.

◄ **Moving closer**

This picture is better than the first one (opposite) but still seems too complicated.

50mm lens; HP5+ rated at ISO 1250; 1/90 sec at f/4. Straight printed on Ilford MGD 25M for 12 secs; f/5.6 at grade 2½.

► **Almost there**

The composition is more stream-lined and satisfying, but it is still very messy, and I felt I needed to change my position by shooting over the hands instead of over the foot.

50mm lens; HP5+ rated at ISO 1250; 1/90 sec at f/4. Straight printed on Ilford MGD 25M for 12 secs; f/5.6 at grade 2½.

▶ **Final prints**

The hands form a
protective circle
around the injured
foot. The picture has
gained strength from
its simplicity. The
print immediately to
the right is cross-
developed in lith
developer; the print
opposite is on the
same paper
developed normally.

*50mm lens; HP5+
rated at ISO 1250;
¹⁄₉₀ sec at f/4. This
page: printed on
Kentmere Art Classic
for 35 secs; f/5.6;
background burned
in for 32 secs; foot
highlights burned in
for 20 secs; shadows
of hand and foot held
back for 12 secs.
Opposite page:
printed on Kentmere
Art Classic for 20
secs; f/5.6;
background burned
in for 5 secs;
shadows of hand
and foot dodged for
5 secs; right side of
foot highlight burned
in for 7 secs.*

Case study 3

Photographing the trouble and strife in the world, the photographer takes on the role of witness rather than creator. When you are in the middle of wars and riots you obviously can't direct the pictures or organize a lovely composition. Telling a visually coherent story in chaos is the name of the game.

I've read that the technique of great reportage photographers is pure instinct and that their compositions are something they were born with. I don't agree. When you are shooting a fast-moving news story it feels as if you're working instinctively, but these instincts are educated ones.

All the visualizing and technical lessons in this book apply just as much to hard news as to anything else. Photojournalists produce order out of chaos because they know all this stuff — because they have learned it.

Much of the visualizing technique is about recognizing in a split second what is a good composition — not composition for art's sake but what works journalistically to tell the story.

► **Explosion**

I heard an explosion and saw that the Belfast youth had torched yet another building. I shot off a few pictures immediately, and the British Army closed in. This is a straight print going for tonal atmosphere, but there are no faces to hold detail in.

80–200mm zoom lens at 200mm; HP5 rated at ISO 800; ¹/₁₂₅ sec at f/4. Straight printed on Ilford MGD 25M for 12 secs; f/5.6 at grade 3½.

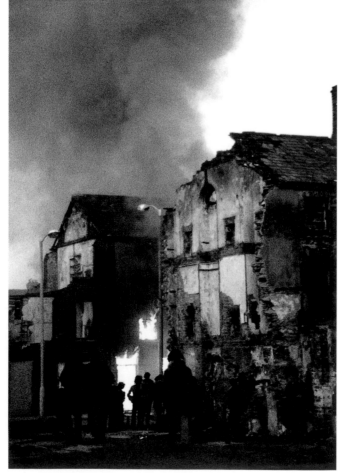

What is difficult to control is the technical side — the exposure and development that will produce an easily printable negative. I have often been shooting away while the little printer on my shoulder is saying, "This is going to be tough to print!" I took the picture on the left for *Paris Match* magazine. It was the middle of the 1970s and the Irish Troubles (as the English put it) were at their most violent.

This kind of story involves long days out on the street, lugging heavy equipment. On this particular day I was finally on my way back to the relative comfort of the hotel when the street army began running towards me.

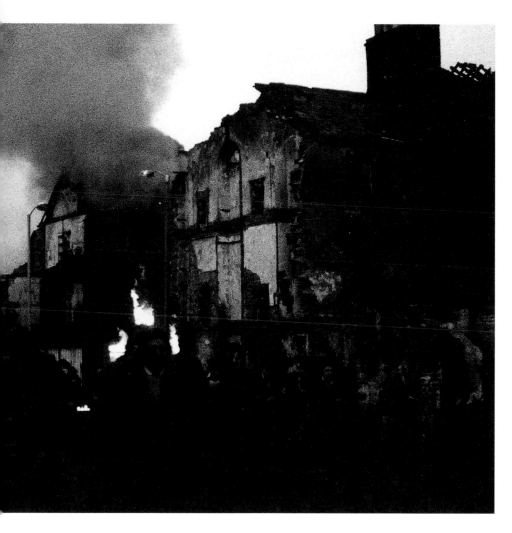

Test print for sky

I remember that there was a beautiful sunset developing in the background, and what with the red flames and black smoke, it would have made a pretty color picture — not at all appropriate to the mood of the situation. The main problem was the huge difference between the exposure in the sky and the exposure for the rioters. I needed both and was aware when I shot it that this would be a difficult negative to print. I started off by exposing this print for the sky so that I could see exactly the difference in exposure between foreground and background.

80–200mm zoom lens at 120mm; HP5 rated at ISO 800; 1/125 sec at f/5.6. Straight printed on Ilford MGD 25M for 12 secs; f/5.6 at grade 3½.

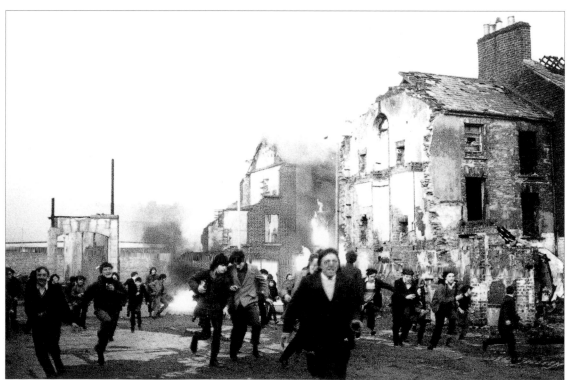

Test print for foreground

This exposure was for the faces. By comparing it with the print above, I could plan my strategy.

80–200mm zoom lens at 120mm; HP5 rated at ISO 800; 1/125 sec at f/5.6. Straight printed on Ilford MGD 25M for 10 secs; f/5.6 at grade 3½.

▶ **The final print**

I made a basic exposure, shading the faces a little, and then had to give lots of burning in to the sky. I also burned in the tricky little areas between the rioters, using a hole in a piece of white card. It took four attempts to make a print that satisfied me and that adequately captured the drama of the evening.

80–200mm zoom lens at 120mm; HP5 rated at ISO 800; $^1/_{125}$ sec at f/5.6. Printed on Forte Warmtone FB for 16 secs; f/4 at grade 3$^1/_2$. Figures in left third of picture shaded for 5 secs; everything above the heads burned in for 14 secs; sky burned in for an extra 12 secs; areas between heads burned in for a total of 20 secs.

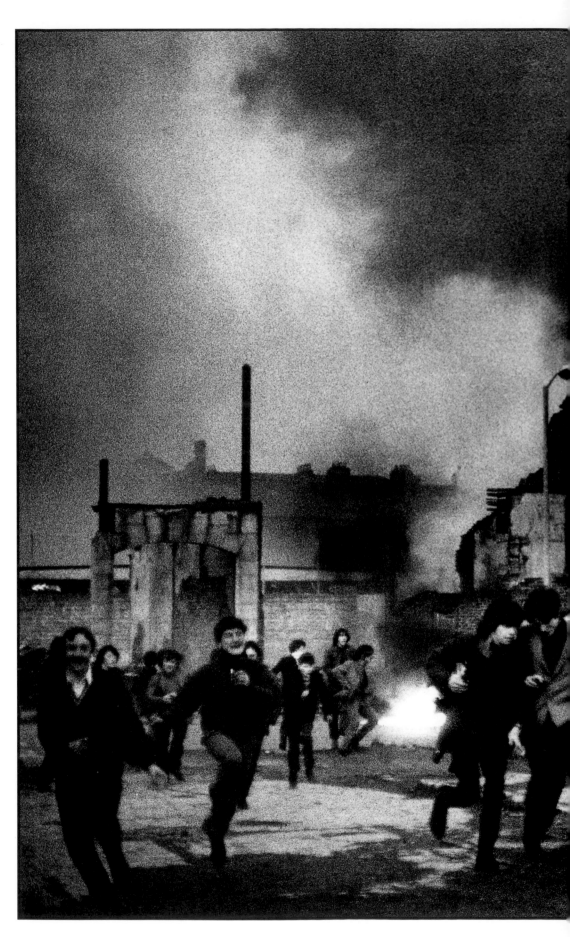

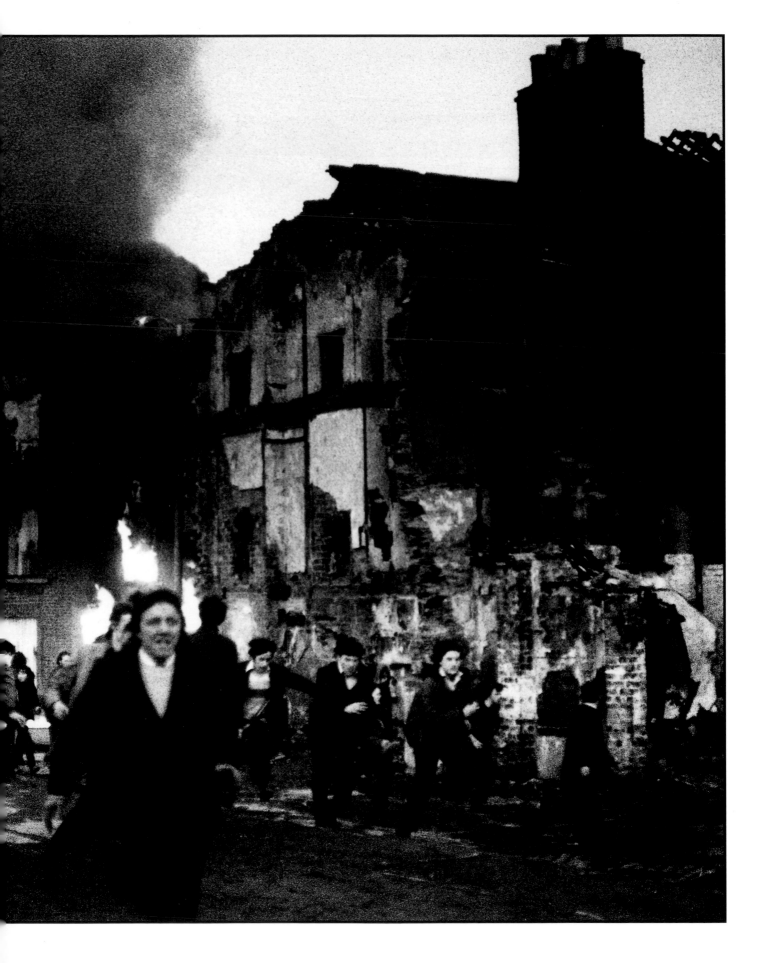

Case study 4

This was not what most blokes would consider a tough assignment: a dozen beautiful girls, well lit from the mirror lights, making up before going on stage at London's Royal Opera House. However, when confronted by such visual riches, it's hard to isolate the definitive image. I took lots of pictures in the dressing room that night because everywhere I pointed the camera the subjects looked attractive.

By the time I shot this session, I had been working with the company for several months. The ballerinas were used to me by then and went on with their make-up, ignoring me.

I decided, after my early flurry of pictures, to concentrate on Sarah, whose face had the classic look of the ballerina. My first few pictures of her were all right but didn't have a really strong compositional style.

When she started brushing her hair, her arms made began to make great shapes. After starting front on, I moved around to concentrate more on her profile and it all came together. I used a 135mm lens wide open at f/2 to throw the shapes of the other ballerinas out of focus. They are still there, but add atmosphere rather than distracting the eye. When you're having trouble with a distracting background, it is always worth trying a long lens and a big aperture to throw the background into soft tonal shapes.

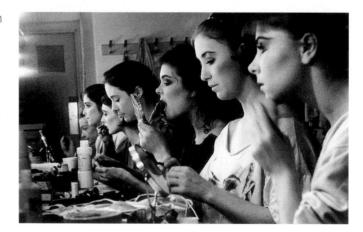

△ Initial shot

My first view of the dressing room — I needed to simplify.

20mm lens; HP5+ rated at ISO 1000; 1/125 sec at f/5.6. Printed on Ilford MCD 1M for 8 secs; f/5.6 at grade 3½.

△ Supporting cast

I took some good pictures, looking along the line, and they make a good shot in the story, but it is not a lead picture.

105mm lens; HP5+ rated at ISO 1000; 1/125 sec at f/4. Straight printed on Ilford MCD 1M for 10 secs; f/5.6 at grade 3½.

Although the composition and her facial expressions were very feminine but strong, I had the problem of having to look straight into the mirror lights. This meant that Sarah was underexposed by about 2/3 of a stop and I had very burned-out highlights.

When I printed the negative. I exposed for the face but needed to shade the hands and brush to hold detail. I then burned in the lights and make-up to gain detail. I made the final print on Ilford warm-tone paper combined with a warm-tone developer, which gives the tonal quality of a light sepia.

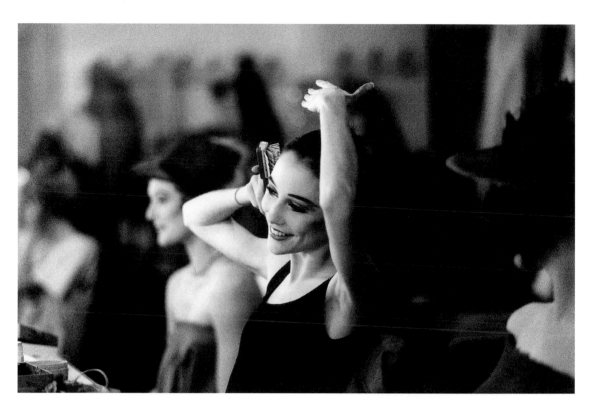

Study of Sarah

I isolated Sarah, but this camera angle does not work with her arm movements.

Perfect profile

With a profile shot, the face is framed by the arms.

Both shots: 135mm lens; HP5+ rated at ISO 1250; ¹/₅₀₀ sec at f/2.8. Printed on Ilford MCD 1M for 11 secs; f/5.6 at grade 3.

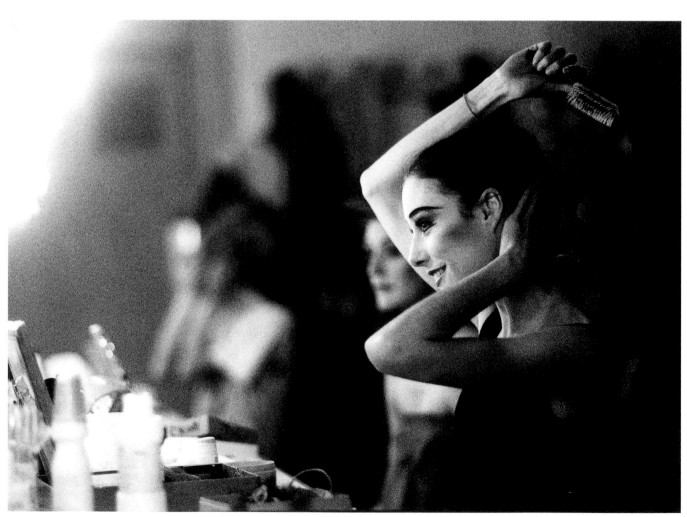

▶ **Final print**

I used Ilford warm-tone paper, in combination
with FilmPlus warm-tone developer, which I
feel has given a softer, more feminine feel to
the print. The lights have received a lot of
burning in, and I have been able to hold a
shape in that corner. I have also given extra
shading to the hands and arms.

*135mm lens; HP5+ rated at ISO 1250; $^{1}/_{125}$
sec at f/2. Printed on Ilford MCD 1M for 25
secs; f/5.6 at grade $3^{1}/_{2}$. Lights burned in for
30 secs, make-up burned in for 15 secs,
hands and brush area held back for 6 secs.*

Case study 5

I was assigned to cover an anti-apartheid demonstration at Twickenham Rugby Stadium, London, by the *Daily Mirror* newspaper. Newspaper editors are usually after one attention-grabbing picture to head their piece, while magazines need a series of shots to make a picture story.

The protesters invaded the field to prevent the match from starting. As the police became more and more aggressive, violence broke out. I started shooting from field level, but with things happening all over a large area I was having trouble making a definitive image that summed up my feelings about the situation — that the police had overreacted to a peaceful protest

and were using more force than necessary on a group of students.

I decided to change my camera angle and went up in the stands. From above I could look over the scene and could see that students were being dragged into a black mass of policemen.

I started to shoot the battered students as they were hauled through the police.

The final picture (page 147) that did the job for me and the *Daily Mirror* gets its impact from composition more than content. I composed using the police as a large foreboding black shape and waited until they ran the arrested students in and swallowed them up. I made several attempts before

I got this picture. It is a classic black-and-white reportage image — there is no pretty color to soften the tension of the tonal arrangement.

Unlike the Belfast picture on pages 136–39, I had time to visualize my picture during this shoot. You have to make decisions very quickly, but that happens anyway when you have adrenaline flowing through the veins.

The printing of the resulting negative did not present great problems but I did have trouble holding some detail in the background, so I gave a little flash in during the development. This has fogged in the background without degrading the black area of the police.

◄ **First attempt**

I started shooting from ground level, but felt unable to illustrate the amount of police presence or get any form to the pictures.

50mm lens; HP5 rated at ISO 600; $^{1}/_{125}$ sec at f/5.6. Straight printed on Ilford MGD 25M for 15 secs; f/5.6 at grade 3.

◀ **Bird's-eye view**
From up in the
stands I was able to
visualize a much
more powerful
composition that
would tell the story
effectively.

*105mm lens; HP5
rated at ISO 600;
¹/₂₅₀ sec at f/8–f/11.
Straight printed on
Ilford MGD 25M for
8 secs; f/5.6 at
grade 3½.*

► **Nearly there**

A strong image of
the event, but the
composition is
rather messy.

*105mm lens; HP5
rated at ISO 600;
¹/₂₅₀ sec at
f/8–f/11. Straight
printed on Ilford
MGD 25M for 10
secs; f/5.6 at
grade 3¹/₂.*

► **The final print**

The police unit had formed into a really strong shape, and as they ran the arrested students in I
waited until all the elements came together and then just had to push the button. It is the tonal
pattern — the threatening black mass into which the student is about to be dragged — that
creates the drama.

*105mm lens; HP5 rated at ISO 600; ¹/₂₅₀ sec at f/8–f/11. Printed on Ilford MGD 25M for 12 secs;
f/5.6 at grade 3¹/₂. Grass burned in for 15 secs; print flashed part way through development.*

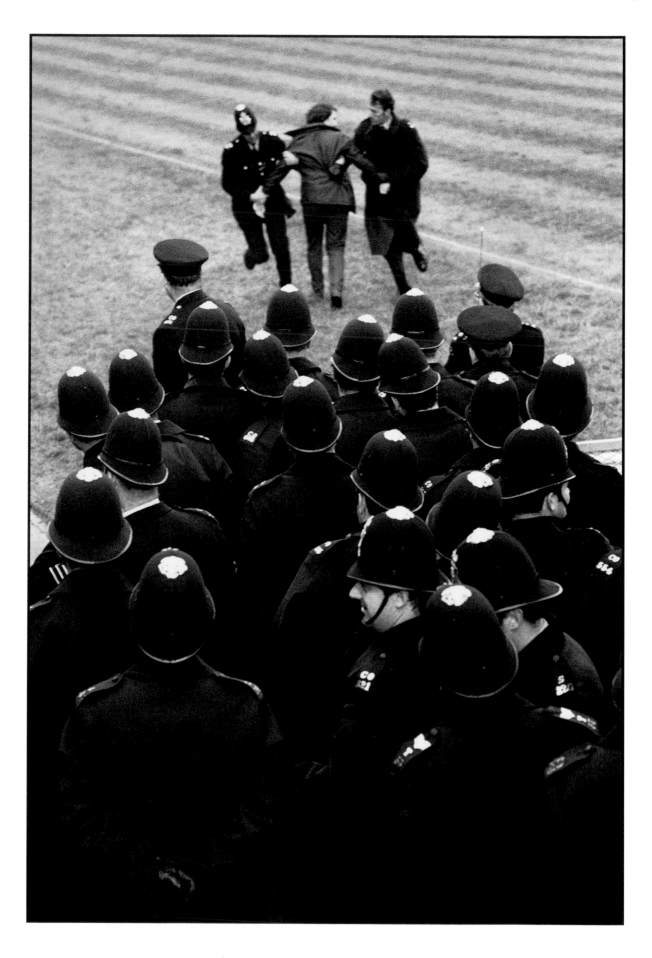

Case study 6

My six-month assignment at the Royal Ballet meant spending time with all the departments behind a production, and not just the dancers. I had several strong elements going for me when I visited the milliners. There was the shape of the hats and a choice of lighting. I also had two hours — plenty of time to make compositional decisions.

There were large windows at one end of the studio and a white wall. I could visualize semi-silhouettes against this wall. At the far end, light was predominantly from the tungsten ceiling lights. I could visualize the potential for reversing the tonal values and using white hats against a dark background.

I chose a low camera angle and a 28mm lens to dramatize the tonal arrangements. As I got into the rhythm of the shoot I concentrated on the positive and negative shapes that were being created in front of me.

▲ **Ballet of the hats**

The negative shapes are well defined and the positive shapes strongly positioned. High-contrast prints emphasize the shapes.

All pictures: 28mm lens; HP5+ rated at ISO 1250; 1/500 sec at f/8. Printed on Ilford MGD 25M for 14 secs; f/5.6 at grade 4½. Face dodged for 3 secs, hands burned in for 3 secs.

▶ Negative shapes

This composition is more dynamic than the two shown below, because the negative shapes betwen the arms/hat and the face are more interesting.

▼ Positive and negative shapes

Below (top) is a very good example of negative and positive shapes at work. The tonal contrast between the positive shapes (almost in silhouette) and the negative shapes (almost white) makes a very strong image. I particularly like the simple silhouette of the face in the bottom picture, although the negative shapes in this image are a little bland.

All pictures: 28mm lens; HP5+ rated at ISO 1250; 1/500 sec at f/8. Printed on Ilford MGD 25M for 12 secs; f/5.6 at grade 4½.

Case study 7

Breakfast was most on my mind as I drove along Route 87, but the sharp morning light cutting across these grain silos caught my eye.

I was in a hurry to begin with, and shot the first frame on a 28mm lens with an orange filter already on the camera. I then decided there was potential for a great shot here so I slowed down.

I went back to the car and got my tripod and camera bag. I decided to keep the verticals vertical, so I used a 28mm perspective control (PC) lens. This enabled me, by raising the front of the lens, to keep the camera back parallel to the silos and get rid of the wide-angle distortion that the normal 28mm was giving me, as I had to tilt up to fit the top of the silos in frame.

I next added a red filter to emphasize the contrast and darken the sky. The slow film (which was already loaded) was ideal for this subject because I wanted to make the image as sharp and fine-grained as I possibly could.

At the risk of stating the obvious, I deem it essential to use a tripod whenever possible. I shoot on tripod for nearly all inanimate subjects and many portraits also.

The tripod slows me down — I have a tendency to shoot too quickly — and focuses my compositional faculties. It also

▼ **First attempt**

This is really a snap shot. I used a 28mm lens with an orange filter that was on the camera.

28–70mm zoom lens at 28mm with orange filter; Delta 100 rated at ISO 80; ¹/₅₀₀ sec at f/8–11. Straight printed on Ilford MCD 1M for 12 secs; f/5.6 at grade 3.

frees my hands to hold filters across the lens while I am visualizing my picture.

The picture needed an extra element. I shot quite a lot of frames with trucks and cars going by. The position of the truck in the chosen picture fills the empty space bottom right and continues the tonal steps from top left to bottom right of frame.

I made the print darker than it looked in real life because I liked the rich tonal pattern that this produced. I burned in the road as I thought it was distracting. Some shading was required in the silos

to retain detail in the metal, and I burned in the sky just a touch to make it more dramatic.

When you find a strong inanimate subject like this — with the composition almost complete in itself — all that you need to do as a photographer is to finish off the job properly. I think finish is a good word. I had a strong subject and dramatic lighting: the only things I did were to straighten out the verticals, adjust the contrast, and make a dramatic print. It just needs good photographic discipline to turn what you see into a good picture.

▲ A more serious approach

I put the camera on a tripod, used a shift lens, and added a red filter.

▶ New element

This is the same set-up as above, but I added another element — the truck. However, its position interferes with the composition.

Both pictures: 28mm PC lens; Delta 100 rated at ISO 80; ¹/125 sec at f/8–f/11. Printed on Ilford MGD 25M for 16 secs; f/5.6 at grade 3. Sky burned in for 4 secs.

► **Final print**

I feel that this picture has got it all together. The truck's position continues the tonal shapes from top left to bottom right of the frame. I have burned in the road. The result is that the quick snapshot has evolved into a disciplined black-and-white composition.

28–70mm zoom lens at 28mm; Delta 100 rated at ISO 80; ¹/₁₂₅ sec at f/8–f/11. Printed on Ilford MGD 25M for 15 secs; f/5.6 at grade 3. Road burned in for 12 secs, sky burned in for 6 secs, all shadow areas held back for 4 secs.

Technical matters

Printmaking is very subjective: give ten printmakers the same negative, and the chances are that no two of them will print it in the same way. Add to that the plethora of materials currently on the market, and the whole subject begins to seem incredibly complicated. The best I can do is share with you some of the things that work for me; you may not always agree with my choices, and as you become more experienced you will undoubtedly discover techniques and favorite formulae of your own, but I hope that my methods, which are based on the experience I have built up over 30 years as a professional, will be of interest.

Film ratings

You often need to change the "official" speed of a film. Your decisions will vary depending on the subject, the conditions you are working under, and the result you want. However, experience has taught me that rating films at the following speeds works for me.

For general reportage work, I rate ISO 400 film (usually Ilford HP5+) at ISO 600. I then develop the film in Ilford Microphen, which gives ISO 600 with no increase in development time and therefore no increase in contrast.

For fine-grain results — studio portraits, still lifes, or landscapes — I rate ISO 400 films at ISO 320, ISO 100 films at ISO 80, ISO 50 films at ISO 32, and ISO 25 films at ISO 20.

When I really need fast film for low light, I rate T-Max 3200 or Delta 3200 at 6400 and increase the development time accordingly in T-MAX developer.

Film Developers

There are many different film developers on the market. The ones listed below are ones that I have found work particularly well for certain situations.

Agfa Rodinal is an excellent developer for slow films such as Agfa 25. It produces high-resolution (sharpness) and can be used at different dilutions to vary tonal contrast.

Ilford Perceptol is an alternative to Agfa Rodinal for fine-grain, high-resolution negatives from slow films. Perceptol effectively reduces the ISO rating of a film by 30 percent.

Ilford Microphen is my favorite all-round developer. It gives excellent tonal range and fine grain and lasts a long time. It effectively increases the ISO rating of a film by 50 percent without any need to increase the development time.

Kodak D76 and Ilford 1D11 — Kodak and Ilford make the same formula for a great alround fine-grain developer.

Kodak HC110 was Ansel Adams' favorite fine-grain developer. By varying the dilution, you can vary the contrast of the negatives.

Kodak T-Max is another favorite of mine. I think it is essential for developing the T-Max range of films; it is also excellent for all push-processing.

Papers

There are so many papers on the market that it is confusing to use all of them. Papers fall into two main categories: traditional fiber-based (FB) papers, made from wood-pulp fibers, and the newer resin-coated (RC). RC papers are a revolution in convenience: the washing time is reduced from 45 mins for FB to 2 mins for RC. RC papers drip-dry flat in minutes, while FB papers require tender loving care.

For ultimate exhibition-quality prints I still use FB papers — mostly

because of the feel and quality look of the paper. RC papers, however, have improved greatly in recent years and the results are now very close to those achievable on FB papers. FB papers generally respond better to toning.

I have used a number of different papers to make the prints shown in this book. I use the Ilford range for most of my work and also Sterling, Kentmere, and Forte. The Kodak range is also excellent, as are Agfa and Seagull papers. I am not saying that Ilford papers are better than any of the others; it's simply that I know them better.

For Ilford papers the following abbreviations are used in the technical specifications that accompany each caption:

MGFB 1K = Ilford multigrade fiber base, glossy finish

MGFB 5K = Ilford multigrade fiber base, semi-matt finish

MGW 1K = Ilford multigrade fiber base warmtone, glossy finish

MGW 24K= Ilford multigrade fiber base warmtone, semi-matt finish

MGD 1M = Ilford multigrade iv resin-coated, glossy finish

MGD 25M= Ilford multigrade iv resin-coated, satin finish

Archival prints

The production of an everlasting print is really the realm of chemists rather than photographers, but the key to successful archival prints is thorough washing. There are several brands of archival washer on the market. They are expensive, but very useful. I use a Nova archival washer for fiber-based prints.

My advice is:

• Develop the print as normal.

• Always use fresh stop bath.

• Use fresh fix (we often forget to change our fix half-way through a day's printing).

• Wash the print for half an hour in 68–70° water (if possible). If the water temperature is below 65°, increase the washing time.

• Selenium tone the print. If you don't have a good exhaust fan, do the process outside. Always use gloves, as the toner is quite toxic.

• Give the print another quick wash — for about 10 minutes.

• Use either Kodak's Hypo Clearing Agent or Ilford Galerie Washaid, and follow the manufacturer's instructions (this removes most of the fiber from the print).

• Give the print a final wash for 60 to 75 mins in big final wash in 68–70° water.

Drying fiber-based prints

Drying fiber-based prints flat is a problem. A well-tried method is to squeegee them off, then lay them on a frame of fiberglass mesh. When dry, place in a 2-inch (5-cm) thick wad of archival blotting paper and weight down. Store in archival boxes in a dry area.

Index

Acknowledgments

Thanks to my friend Graeme Harris for his support and printing tips over the years; to Margaret and Katherine Harris for a great job typing my messy writing; to Susan Berry for her invaluable creative contributions to the book and her support in difficult times; to Sarah Hoggett for her great enthusiasm for the project and love of photography in general; to the editors Chris George and Paul Harron; to Simon Brockbank for lots of unglamorous toil; and to all those brave folk who are the subjects of my photographs — thanks a lot.